POSTCARD HISTORY SERIES

Mooresville

POSTCARD HISTORY SERIES

Mooresville

Henry A. Poore

ARCADIA
PUBLISHING

Published by Arcadia Publishing
Charleston, South Carolina

Printed in the United States of America

Library of Congress Control Number: 2023932714

For all general information contact Arcadia Publishing at:
Telephone 843-853-2070
Fax 843-853-0044
E-mail sales@arcadiapublishing.com
For customer service and orders:
Toll-Free 1-888-313-2665

Visit us on the Internet at www.arcadiapublishing.com

To My Tonic.

CONTENTS

ACKNOWLEDGMENTS

Unless otherwise noted, the postcards pictured in this book come from the postcard collection of the Local History & Archives Department (LHA) of the Mooresville Public Library. The LHA holds a large collection of postcards acquired from various donors and purchases. The nucleus of the collection is the Mooresville Postcard Collection (digital.mooresvillenc.gov/digital/collection/p16711coll6), which has been curated by LHA staff through the years as a means of capturing an ephemeral part of Mooresville's history. The author would like to acknowledge that this collection, as well as this book, would not have been possible without the generosity of donors to the LHA—thank you.

Very special thanks go to Sara McKee, digital archives specialist, and the other half of the LHA. I am grateful for her suggestions, editorial notes, assistance, support, and more on this book, as I could not have done it without her.

I am also grateful for the support, encouragement, and help from Amy Jarvis of Arcadia Publishing, who was very patient with this novice writer. Her suggestions and support were greatly appreciated and welcomed in guiding me through the publishing process.

I am also exceedingly grateful to the Town of Mooresville, the Mooresville Public Library, and the citizens of Mooresville who have made it possible through their support and donations to make the LHA the main repository for the history and archives for the town. Their support makes it possible for patrons to learn about the history of Mooresville both through our collections as well as through publications such as this book. Thank you.

INTRODUCTION

At the start of the 20th century, postcards were a new form of communication enabling people to send a note or greeting to family and friends without the formality and rules associated with letter writing. With a picture on the front and space on the back for a few short lines, postcards allowed senders to ask how someone was doing, tell them the news of the day, or simply show where they were in their travels, all on a three-by-five-inch piece of paper. Postcards became a staple in our literary culture, yet they did more than allow us to send a quick note or show others the sights they were missing in our travels; they also documented the ever-changing landscape of cities and towns while capturing small moments of historical and genealogical importance. Pieces of information that would not have normally been conveyed within the context of a letter or telegram were often scribbled hastily across the back of a postcard. Often, it was an announcement of a marriage, birth, or death, or the latest news about someone's health with more to follow later in a letter. However, postcards were not just about the information on the back; the image on the front told a story as well.

Captured on the front were often images of local street scenes, people, scenic views, or special events. The images were designed to capture attention in the hope that they would be purchased, while at the same time capturing a moment in the ever-changing life of a town. Photographers, both amateur and professional, snapped pictures that in time would document the changes, growth, and development that were occurring in towns and cities, recording the changing streetscapes, neighborhood developments, and shrinking rural landscapes. This has caused postcards to now be seen as important historical documents that provide a record of change over many years. For small-town America, they have become a main source of documentation of the early days as well as a showcase of growth through the decades. Mooresville was no exception.

Connected first to other towns and communities by major roads and later by the railroad, Mooresville grew as a tourist destination with its natural spring-fed spas, scenic vistas, and a growing town. People traveled to Mooresville on the railroad from all around for the spas, to visit family and friends, or simply as a stopover in their travels. By the late 1870s, visitors were writing home or to others about their visits and travels on the newest means of communication: postcards. Mooresville became more connected to the rest of the world through a new way of communication that was shorter, faster, and more convenient, and life would never be the same.

Incorporated on March 3, 1873, as the Town of Mooresville, the community once known as Deep Well started its second phase of growth, which would be documented in postcards. While no postcard from the early days of Mooresville has been found showing the spas and farms that populated the area, by the 1890s, this all changed. With the incorporation of the new town came

new people and new businesses, such as photography studios, drugstores, and printshops, all playing a role in the new postcard industry. By the 1890s, most of the postcards in Mooresville were printed by local photographers and drugstores, with the most prominent being Goodman Drug.

Owned and operated by George Goodman, Goodman Drug produced a majority of the postcards of Mooresville that have survived to today. While there is no documentation as to why Goodman was the largest producer of postcards in Mooresville, it has been speculated that the postcards were intended as a marketing scheme for the drugstore. In the early days, drugstores, stationery shops, and print shops saw the potential for marketing created by postcards. Cards with local scenes such as images of the town or the local landscape were the most popular, as they showed the recipient a small glimpse of where the sender was and what they might have been doing. For businesses and local photographers, postcards were a way of marketing their skills and services in a way that went beyond print advertisements. Goodman, working with local photographers, capitalized on this new form of advertisement by printing cards that showed new buildings, people, and sights in and around Mooresville while noting his store's name on the cards. Drawing on the business of travelers wishing to send a note home to family and friends, Goodman published postcards that were designed to entice people to come into his store to purchase a postcard or two, thus promoting both Mooresville and his business.

While most of the postcards produced by Goodman show streetscapes of Main and Broad Streets, it does not appear that he published images of any of the neighborhoods or surrounding countryside. Goodman's focus was on the main draw of the day—the growing town. His postcards captured the ever-changing streetscape of downtown as new buildings were built, giving us today a snapshot of the development and growth of the town as it was occurring. These postcards have become a valuable historical record of Mooresville's past, as today many of the buildings they show have been razed to make way for newer ones or have been altered from their original design. As Goodman's drugstore was on Main Street, photographing the surrounding street scenes was an obvious course for him to take, while some other local photographers branched off Main Street to capture the growth occurring elsewhere around town.

While there are not many postcards from the turn of the 20th century, the ones that have survived show many of the other buildings that were being built in town. Goodman was not the only publisher of postcards, as many were published by companies outside of Mooresville such as in Asheville or other states. These postcards show the new school building, new churches, and some of the surrounding countryside. While these images show the town as it developed out from Main Street and though they focus mainly on one or two buildings, they also, most importantly, show the surrounding houses and landscapes around them. Buildings such as the new First Presbyterian Church were prime subjects for postcards, and while many photographers worked to capture the imposing new Gothic building, they also captured the houses and streetscapes around it. This was unintentional perhaps, but also critical to the historical record, as these images record the styles of houses, the layout of streets, and the use of land for community gardens or pastures not normally found in other records. In some cases, photographers did set out to capture the landscape, such as the Catawba River, local granite quarries, laborers working in the fields, and even the new town cemetery. Yet while the fronts of the cards may have detailed historical changes, the messages on the back of the cards supported the growing genealogical record.

The main purpose of a postcard is to write a few lines and send the card to someone, rather than hold onto it as a memento. From "Wish you were here," to "Grandmother is doing better after her surgery," to "There is a new addition to the family," these small remarks particularized genealogical information outside other traditional avenues of family research. The senders of these postcards chronicled events that might not have been recorded in letters or other documents. Notes about potential romances, travel plans, visits, and family events make up many of these postcards, giving us important insights into family histories.

While most of the postcards from this period are from people who were traveling, there are some from residents of Mooresville written to family and friends in other communities. These cards have become valuable resources for genealogists and cultural historians for the information they provide

that is often not documented elsewhere. For Mooresville, these postcards provide an insight into the town and the life of the people that play an important role in documenting its history.

The postcard collection of the Local History & Archives records this understanding of postcards as small windows into the town's history. Starting in the second half of the 19th century, these postcards show how the town changed and grew, who was visiting, who was passing through, where they were going, and how daily life was conducted. Through the images, we can see how the town progressed through the decades with new buildings, new streetscapes, and new areas. In addition, postcards add to the historical record by capturing people's thoughts and reactions to social events or changes, such as marriages, births, deaths, world events, and community news. Postcards were a way of quickly capturing a moment and sharing it with others. While many of the cards within the collection were written by people visiting or passing through town, they show the growth and changes in Mooresville over time, capturing a snapshot of life as it once was.

The LHA postcard collection shows life in Mooresville over several decades. Each card documents not only the small moment in the sender's life but also a part of the ever-changing landscape of Mooresville. They show buildings and streetscapes that are no longer present, along with the changes that have over occurred over the years. They also show the social side of citizens as well as the people who visited, recording interesting tidbits of information. Laid out within this book is the timeline of Mooresville through the years.

One

EARLY POSTCARDS

The use of postcards in Mooresville started in the early 1890s, when the popularity of postcards was spreading. Early examples were simple cards with drawn images or simple phrases written on them such as "Welcome to Mooresville," or "Peace on Earth." Others were blank cards where the sender could write a note, with just the address on the front. By the turn of the 20th century, images of people, places, animals, and even stitching started to appear on the front. After 1900, they tended to be a mix of images of buildings along Main Street, animals or holiday scenes, and picturesque scenes. Many of the cards were at first simple messages embossed or printed onto the front of the card before the technology of printing photographic images improved and became more affordable. Embossed cards were easier and faster to produce, which made them more affordable and more abundant than photographic cards. Yet as the century progressed, photographic cards became the card of choice.

At first, many of the photographic cards were simple black-and-white images; however, as newer printing techniques were invented, cards became colorized with bright clothing, blue skies above buildings, and varying hues of many buildings. Some of the earlier postcards were hand-colored to enhance the image, though this was not the general rule of thumb. Hand-colored cards were difficult to produce due to the time and skill required. Yet those that have survived show images in greater detail, often more than standard colored cards. Details that are not normally captured in the standard process are highlighted in the work of the coloring artists such as building details or clothing. While it is not known if the coloring of images increased the sales of postcards in general, it is clear they had some popularity, as many have been preserved.

With the colorization of postcards came a new focus on images of buildings, downtown scenes, and various other subjects that became the central theme of many of the early postcards of Mooresville. The growth of the town in the early 20th century offered opportunities for new and exciting images from churches to the hotels on Main Street, all captured in the photographer's lens: Mooresville was on the move, and postcards were there to record it as it happened.

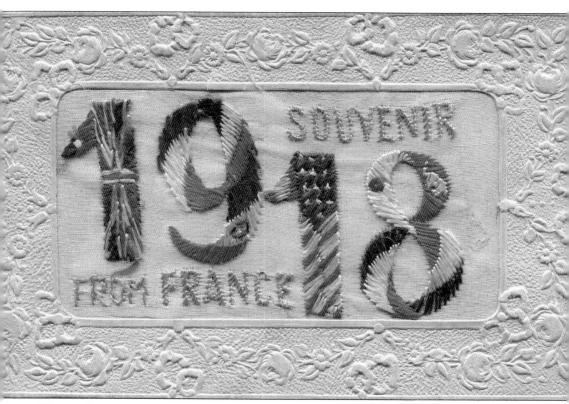

WORLD WAR I POSTCARD, 1918. This postcard was produced in 1918 at the end of World War I as part of the celebration of the end of the war. The year is woven onto the card with thread in the colors of the nations that fought in the war. Each number is stitched with the colors of the flag of one of the nations, along with the words "Souvenir from France." The edges of the card are embossed with flowers. This card represents the type that was brought home by many of the men who served in the war and that soldiers from Mooresville would have sent home from the front.

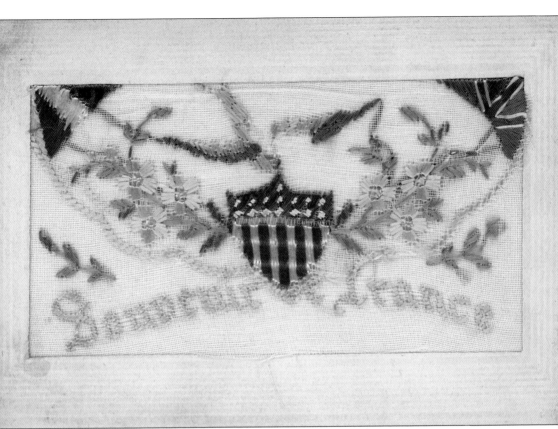

WORLD WAR I VICTORY CARD, 1919. This is another representation of the type of card that was brought home after World War I. This is an embossed card with a stacked border and a woven design. In the corners are the flags of England and France, with an American shield in the center. There is a flower and vine motif around the center section with the phrase "Souvenir of France" across the bottom. These cards were popular with servicemen to send to family and friends. The stitching on the card was possibly done by hand.

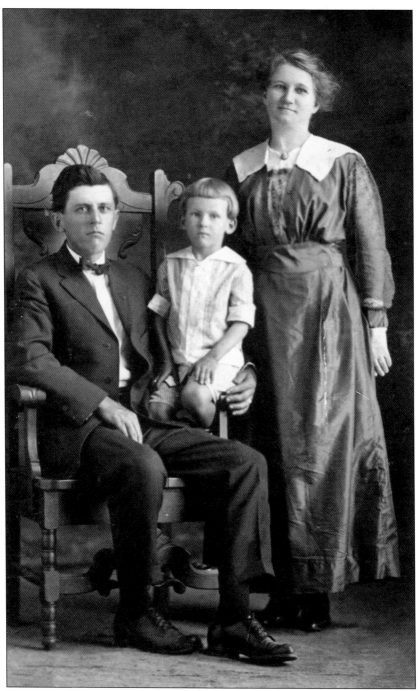

HENRY BOWEN FAMILY, C. 1914. This photograph shows Henry and Peggy Bowen and their son Wendell in 1914. This was a fast and easy way to send information to a large group of people such as family members. Postcards such as this were popular in the early part of the 20th century, as one could send a brief message or note outside the formality of a letter. While this card is originally from South Carolina, it is a typical example of family cards that were produced by local photographers in Mooresville during the early part of the 20th century. (Author's collection.)

EASTER CARD, C. 1900. This is an early embossed card with some coloring. It is a simple Easter card showing two rabbits and a bird on a blue egg. These were typically produced around the turn of the 20th century as general greeting cards and were sold in drugstores and stationery shops in the Mooresville area.

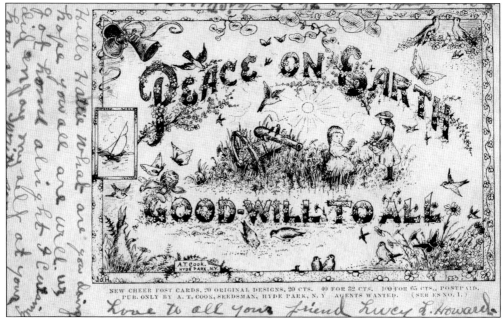

"PEACE ON EARTH, GOOD-WILL TO ALL," 1901. This card was sent to Hattie Horton in Mooresville by Lucy Howard in 1901. The front of the card has a simple stenciled message in black lettering with the seller's information across the bottom. It was made by A.T. Cook in Hyde Park, New York. The back is undivided, with the same stencil work in the top left corner. There is no room for a message on the back, so Lucy Howard penned her message on the front of the card. The card was canceled in Sherrills Ford and Catawba, North Carolina.

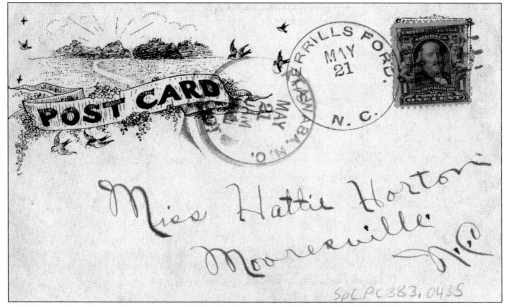

A.T. COOK SEEDSMAN POSTCARD, 1901. Cook ran a seed business in New York that sold to farmers across the United States. He published postcards as well to advertise his business. This is a stenciled postcard with the message or image printed in black ink. This style of card was not designed for personal messages, as there was no space on the back. The front was meant to be the primary message.

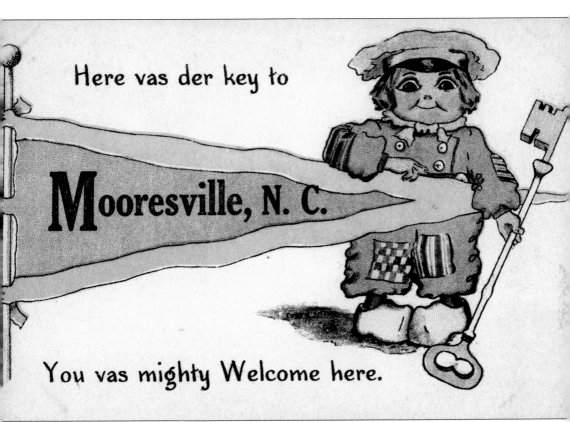

Here vas der key to

Mooresville, N. C.

You vas mighty Welcome here.

"**HERE VAS DER KEY TO MOORESVILLE**," **C. 1900.** This card is one of the earliest ones for Mooresville printed in color. It informs the receiver that they are welcome in Mooresville and that the card is an implied key to the town. There is no indication on the back of the card as to who made it, as the back is plain with no writing. Color was a new technical innovation for postcards at the turn of the 20th century.

Girls are so Affectionate in

Mooresville

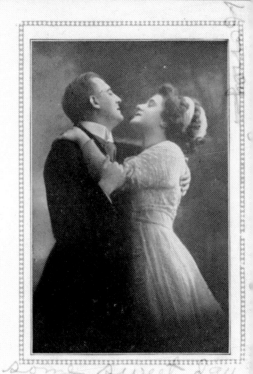

You're Made Feel at Home

"GIRLS ARE SO AFFECTIONATE IN MOORESVILLE," 1913. Sent on November 13, 1913, this interesting card is one of the earliest to have a photographic image printed on the front. There is no publisher listed on the back, but it is divided for space to write a message and an address. The image of a man and woman embracing is framed in a simple box with an image of a globe and clouds to the side. The name "Mooresville" is in the middle of the globe with the main message printed at the top and bottom.

18

THIS IS THE KIND WE RAISE
Near Mooresville, N. Car.

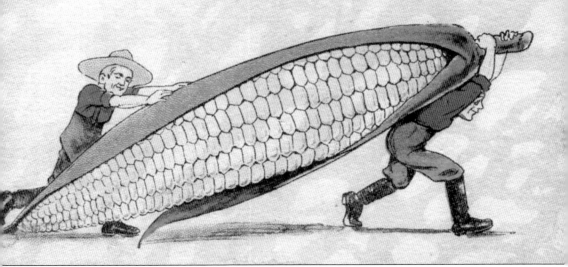

"THIS IS THE KIND WE RAISE," 1916. This card sent in 1916 to Myrtle Lawton in Statesville, North Carolina—with the postage stamp removed—makes note of the agricultural industry of the Mooresville area. Note that it reads, "Near Mooresville, N. Car.," indicating that the reference is to the farms in the area. The card is divided on the back but it is interesting to note that the sender did not write their message in the normal left-to-right manner, as indicated by the space, but from the middle line down and flowing up the sides. There is a lack of punctuation in the writing, in much the same manner as a telegram.

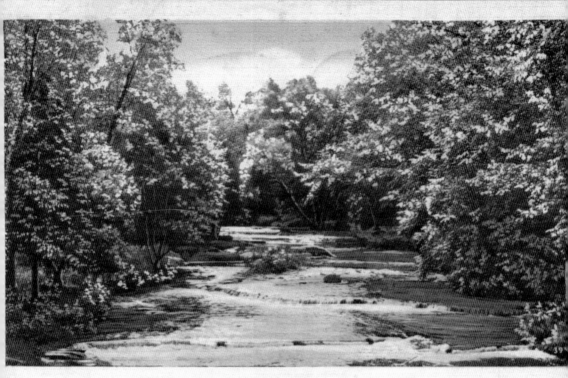

GREETINGS FROM MOORESVILLE, N. C.

"Greetings From Mooresville," 1938. One of the more popular attractions near Mooresville in the early years was the Catawba River. This postcard, sent in 1938, shows a section of the river. Many scenes like this no longer exist due to the flooding of the river to create Lake Norman. The sender of this postcard must have been a new visitor to the area, as she wondered why, with all the water around, there were no lighthouses—at least none she could find.

14103

WOODED ROAD, MOORESVILLE, 1930s. This postcard shows a scenic tree-lined road most likely in the countryside around Mooresville. The writing on the back is representative of an Eastern European language. The sender appears to have been writing to friends in Massachusetts and describing their travels through North Carolina.

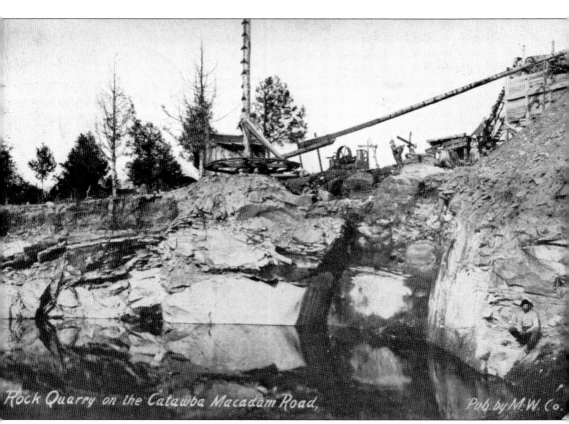

Rock Quarry on the Catawba Macadam Road, Pub by M. W. Co.

"ROCK QUARRY ON THE CATAWBA MACADAM ROAD," 1912. Sent in 1912, this postcard shows one of several rock quarries in the area. The rocks mined from these quarries were used in many of the houses and buildings in Mooresville. This quarry may have been abandoned at the time the photograph was taken. On the front, the water in the quarry is visible, with a man sitting on the right. The sender was writing to let her friend know that she had received her letter and that everyone had been sick but they were getting better.

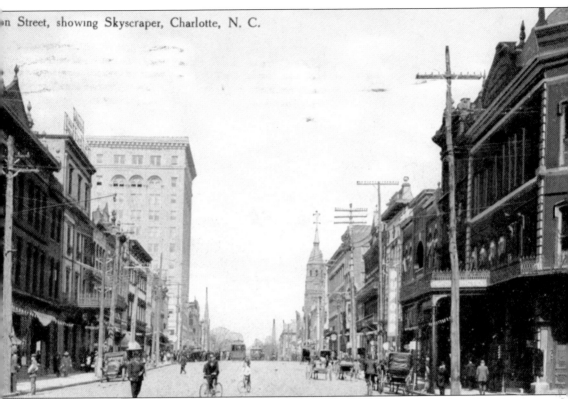

"TRYON STREET, SHOWING SKYSCRAPER," 1911. This postcard is of downtown Charlotte, North Carolina, and is postmarked 1911. The recipient was Julia Stirewalt of Mooresville from her cousin Mary. The message on the back concerns a lady's requisition of four dozen of Julia's wafers. She states that she told the lady the price. While telephones were available at this time, this card represents the typical way many people still communicated with one another in the early part of the 20th century. While it was not faster, it was cheaper than a long-distance phone call.

CHARLOTTE, NORTH CAROLINA, 1911. The message on the back of this card is from Mary writing to her cousin Julia in Mooresville regarding the price and purchase of wafers that she made. This is an example of farmers, bakers, and others conducting business. As it was expensive to call or send a letter, postcards were a quick and cheap way of placing orders or making requests. It is thought that Julia ran a bakery in Mooresville.

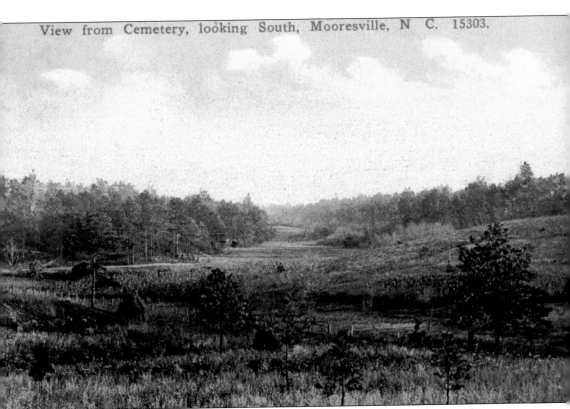

View from Cemetery, looking South, Mooresville, N. C. 15303.

"VIEW FROM THE CEMETERY, LOOKING SOUTH," 1890s. This postcard shows the area that was becoming the town's first cemetery: Willow Valley. The view is from the top of the cemetery, facing south down the valley from which the name is taken. On the back of the card is a simple note from Moses telling Mrs. W.W. Dugan that he will not say goodbye. The date of this card is not known, but the photograph was possibly taken around the turn of the 20th century.

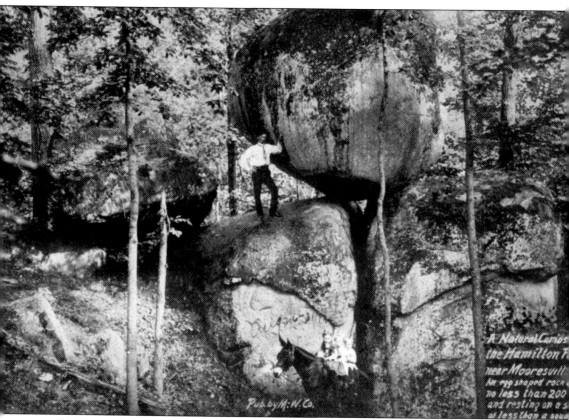

Inside the image, partially visible text reads:

A Natural Curios...
the Hamilton F...
near Mooresvill...
An egg-shaped rock...
no less than 200...
and resting on a s...
of less than a squa...

Pub. by M: N. Co.

"A NATURAL CURIOSITY," C. 1900. This egg-shaped rock that weighed over 200 tons sat on a surface of less than a square yard on the Hamilton Farm near Mooresville. For decades, people tried to push the rock over, but it would not move. There was no support that could be seen. How and why the rock was formed there was never answered. This photograph was taken at the turn of the 20th century and shows the rock in its original position. It is not known if the rock is still there today or has fallen. (Courtesy of Carolina Collection Photographic Archives, Wilson Library, UNC-Chapel Hill.)

Two

TOWN

In the 1730s, settlers started to move into what was known as the Carolina Backcountry from Virginia and South Carolina. A central location along the King's Highway and other major roads surrounded by fertile lands with deep wells and many tributaries leading to the Catawba River, the area quickly became a prominent community. Many of the early settlers were of Scotch-Irish descent and settled in the Piedmont between the English in the east and the Highland Scots in the west. In 1781, Gen. William Davidson led a group of soldiers to fight Lord Charles Cornwallis as his army crossed the Catawba River at Cowan's Ford. In the mid-1850s, the first railroad lines were run through the area. By the 1860s, the community had grown into a prosperous village of large farms; however, by 1864, growth had halted as the railroad company removed the tracks to salvage the iron for other purposes during the Civil War. As the war came to a close, many in the community realized that for it to endure, they would need to form a town. On March 3, 1873, the Town of Mooresville was incorporated. With incorporation came new growth and development, which was boosted when, in the early 1880s, the Atlantic, Tennessee & Ohio railroad connected Charlotte with Danville, Virginia, with a line running through Mooresville bringing with it a new age of growth.

The new town was laid off in a one-mile radius from the depot, which marked the center of town. The business district was divided into two separate sections: Main Street on the east side of the tracks and Broad Street on the west side. Laid out within a block around the depot, the business district was small, but by the late 1880s, Mooresville was a growing and vibrant community of businesses, mills, and farms. The 1890s saw a major boom in growth for Mooresville with new textile mills, a flour mill, ironworks, hotels, and other businesses. The wooden structures of the early businesses were replaced with new brick buildings, and by 1900, Mooresville's downtown had grown past the small one-block radius around the depot. During the early part of the 20th century, new neighborhoods were created and the business district expanded to include all of Main and Broad Streets. By the 1950s, downtown Mooresville was a thriving area with shops, cafes and restaurants, a hotel, movie theaters, and more.

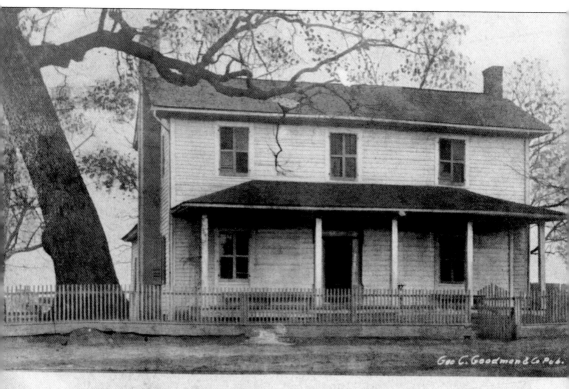

OLD MOORE HOUSE, FIRST RESIDENCE IN MOORESVILLE, N C.

JOHN FRANKLIN MOORE HOME, 1920S. This is John Franklin Moore's home around the 1920s. Moore was one of several men who worked to incorporate Mooresville in 1873 and whose family the town name is taken from. The home was built in the mid-19th century on Main Street in a large curve, giving Moore the advantage of seeing down the street into town. While not the first residence in Mooresville, the house is a typical farmhouse style that was predominant in the area at the time. It stood until the 1930s, when it was damaged by fire and torn down.

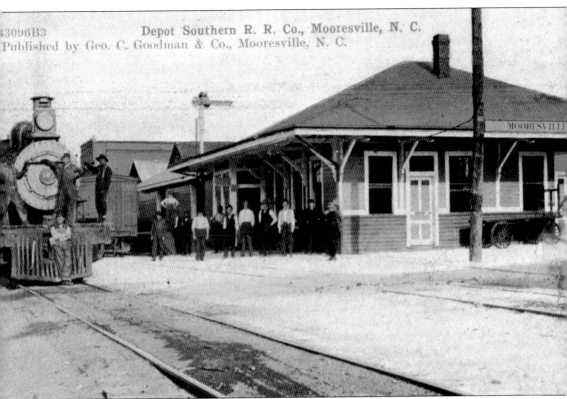

"Depot Southern R.R. Co.," 1920s. This postcard from the early 1920s shows the second depot for the town. Built on the same spot as the first, the second depot allowed more tracks to be added along the main line, which can be seen to the right of the steam engine. Note the men on the engine as well as in front of the depot, who appear to be crew members for the train, depot employees, and possible townspeople.

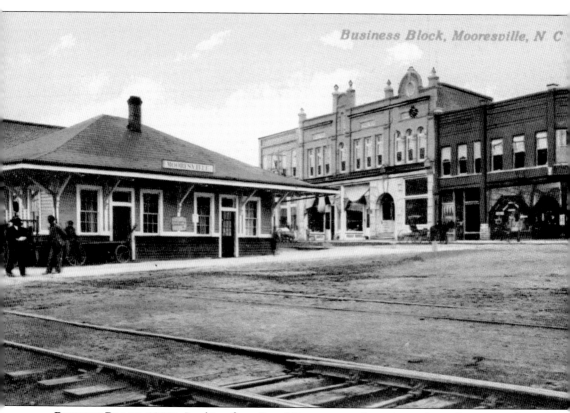

BUSINESS BLOCK, 1900s. Looking from Broad Street across the train tracks to the center of town, this postcard shows the second depot on the left and the buildings, from right to left, of Goodman Drug, the First National Bank, and D.E. Turner Hardware. These were some of the first brick buildings on Main Street. The note on the card is dated August 1, 1916, to Myrtle Lawson in Statesville, North Carolina. The sender informed Lawson that "mamma and aunt Lou" were coming on the next train to see her Friday morning and requested that she meet them. It was also noted that they would go by way of Mooresville, which indicates that they probably lived in the countryside around Mooresville.

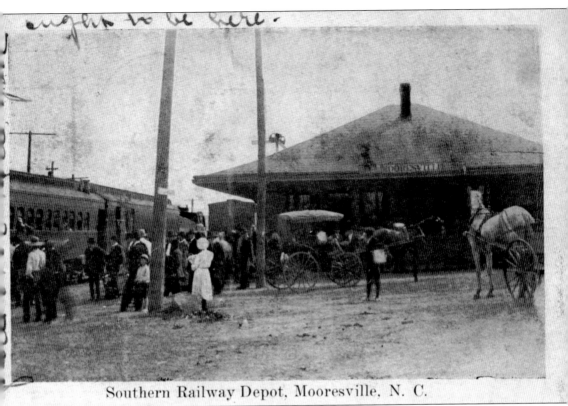

ought to be here.

Southern Railway Depot, Mooresville, N. C.

"SOUTHERN RAILWAY DEPOT," 1890S. This photograph, possibly taken at the turn of the 20th century, shows the second depot along with a train and people waiting. Note the town sign along the roof as well as the waiting carriage. The two poles are on the sides of what is Center Avenue today. It is also interesting to note the dirt streets as well. The note along the edge reads, "It's a mighty fine place over here. You ought to be here." (Courtesy of North Carolina Collection Photographic Archives, Wilson Library, UNC-Chapel Hill.)

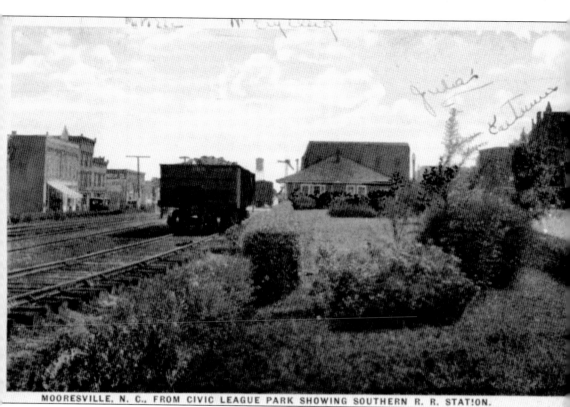

MOORESVILLE, N. C., FROM CIVIC LEAGUE PARK SHOWING SOUTHERN R. R. STATION.

CIVIC LEAGUE PARK, 1900s. This park was alongside the railroad lines that ran through Mooresville. The depot is at rear center, with Broad Street on the left and Main Street on the right. The water tower in the background was in an area called Junction. Note the names on the front of the card, which may indicate the sender's home, or possibly where they work.

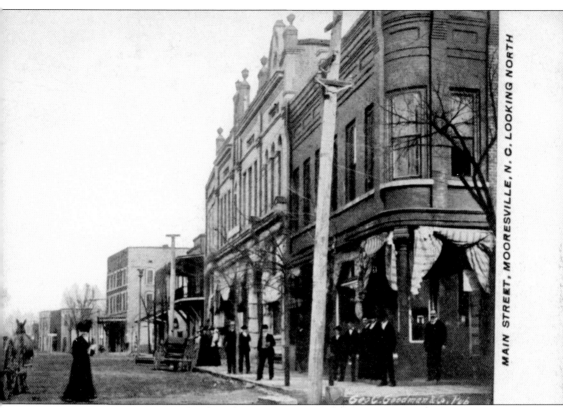

MAIN STREET, 1909. This is a view of Main Street looking north from the intersection of Center Avenue. The buildings on the right start with Goodman Drug Company, which also printed the card (bottom right), with First National Bank and D.E. Turner Hardware following The two buildings with balconies are the Central Hotel (foreground) and the Commercial Hotel. It is also interesting to note that all the people in the image have stopped and are looking at the cameraman. The sender of the card told her friend that she liked the place and inquired if she had seen her man.

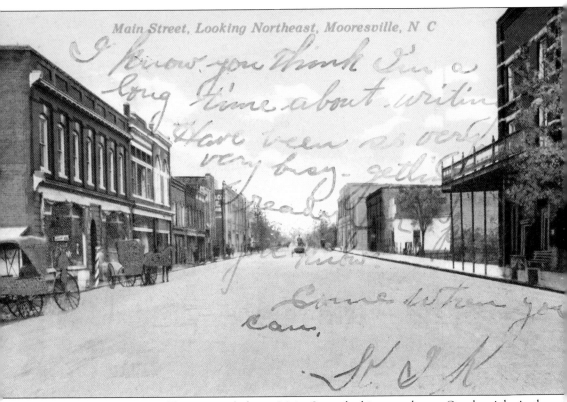

Main Street, Looking Northeast, Mooresville, N C

I know you think I'm a long time about writin Have been so very very busy gettin ready ... Come when you can.

H. & K.

MAIN STREET, 1915. This postcard shows Main Street looking northeast. On the right is the Commercial Hotel, followed by the McNeely Livery stable. The large brown building in the background on the left is the Merchants and Farmers Bank. There are several people as well as two horses and buggies on the left; a barber pole can be seen on the sidewalk behind one of the buggies. In the middle of the street is a man standing in front of what appears to be a wagon. He is wearing a hat and possibly a suit as he is riding out of town. This image was originally a photograph that was hand-colored for this postcard, which contributes to the blurring of the people and horses. The postcard has two messages on it: one on the front and the other on the back.

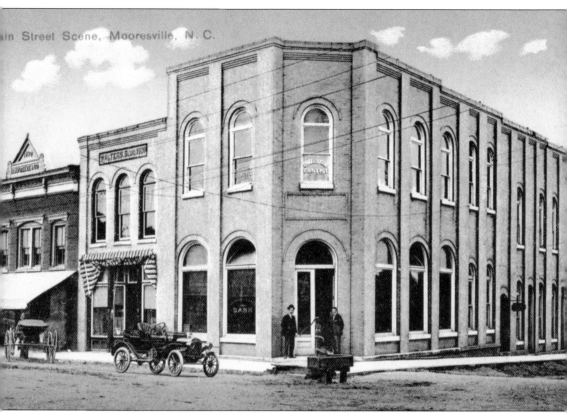

"MAIN STREET SCENE," 1914. This is the Merchants and Farmers Bank, with the dentist Dr. C. Voils on the top floor. To the left is the Walters building and W.F. Freeze Co. The bank was the largest commercial building on Main Street at the turn of the 20th century. Note the watering trough for horses in front of the front door, the two men standing by the door, and the automobile with a buggy just behind it. The back of the card shows that it was published by Geo. C. Goodman & Co. and printed in Germany.

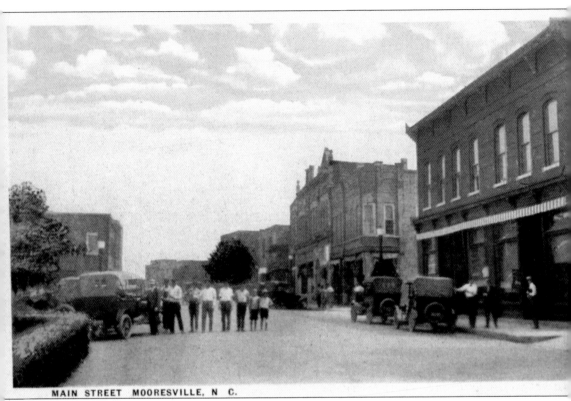

MAIN STREET MOORESVILLE, N. C.

MAIN STREET, 1920S. This postcard shows Main Street looking north. The large building on the right in the foreground is the Rankin Dry Goods store. The bushes and tree on the left mark the edge of the Civic League (now Moore) Park. The larger buildings in the background are Goodman Drug, D.E. Turner, and the Central Hotel, with the Commercial Hotel just behind the tree.

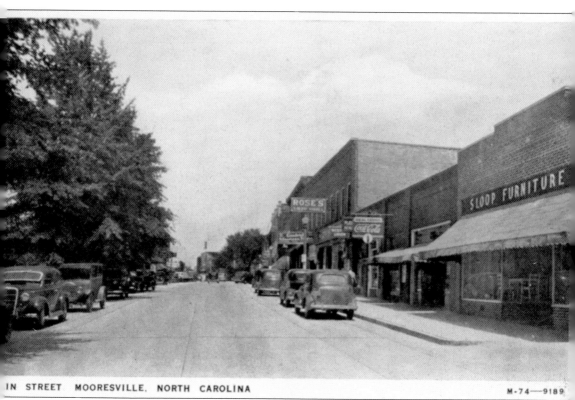

IN STREET MOORESVILLE, NORTH CAROLINA M-74—9189

MCLELLAND AVENUE AND MAIN STREET, 1950. Main Street is seen here looking north from McLelland Avenue. The trees on the left are around Moore Park. The buildings on the right show the post–World War II building downtown, as many of the older buildings were torn down and replaced with newer and more modern buildings. One common feature was the large plate-glass windows on the front to allow more light into the stores.

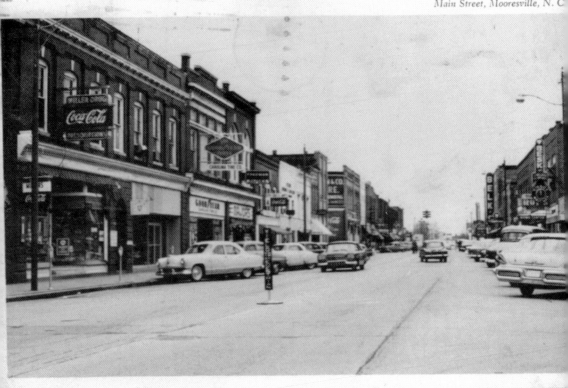

MAIN STREET, 1959. This view looking north on Main Street shows some of the stores downtown. The postcard shows the first downtown development that occurred after World War II. New features such as electric signs, new streetlights, more modern storefronts, and a redesign of parking along Main Street were some of the features that made downtown more friendly to shoppers.

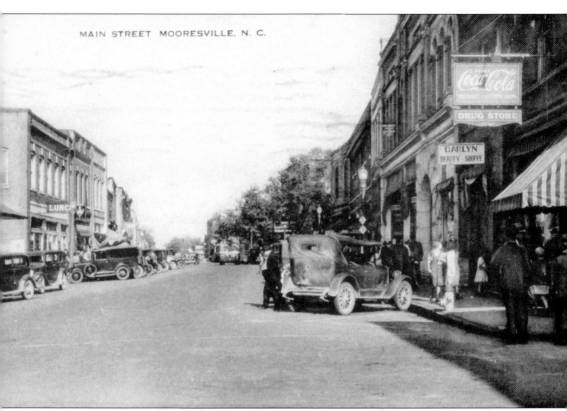

LOOKING NORTH FROM CENTER AVENUE, 1935. This postcard shows Main Street looking north from the intersection of Center Avenue. It shows downtown before the post–World War II redesign and expansion. Note the clothing of several people on the sidewalk as well the signs of several of the business hanging above, which were common in the Depression era. Also note that Main Street is not paved and there are several trees in the background still lining the street.

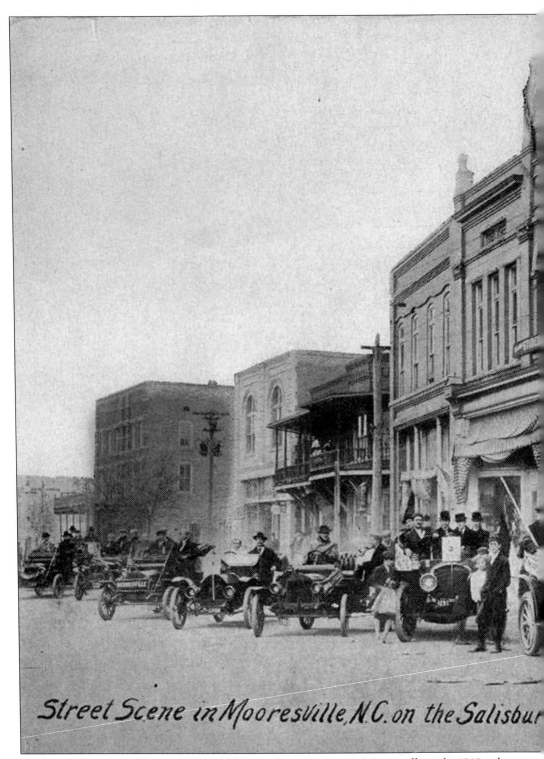

Street Scene in Mooresville, N.C. on the Salisbur

SALISBURY-ASHEVILLE HIGHWAY, 1910S. This was the street scene in Mooresville in the 1910s when Main Street was part of the Salisbury-Asheville Highway. Note the addition of two new buildings to

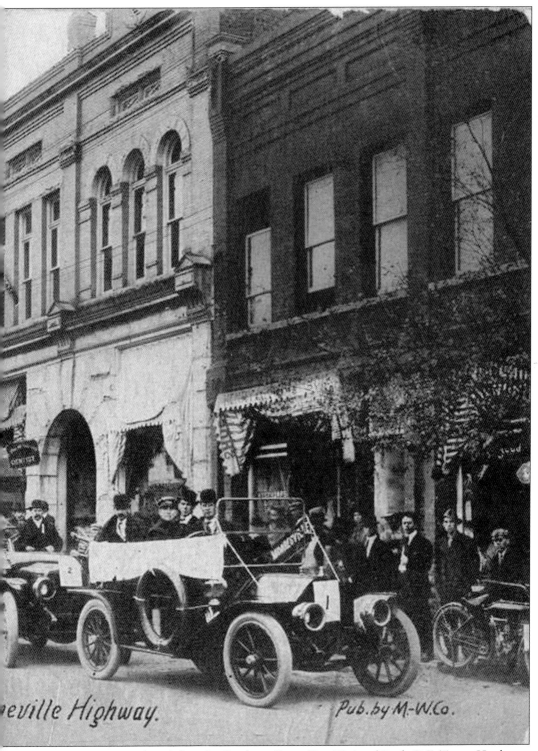

eville Highway. Pub. by M-W Co.

Main Street. From right to left are he Goodman Drug, First National Bank, D.E. Turner Hardware, a lodge hall, the Central Hotel, a furniture store and barbershop, and the Commercial Hotel.

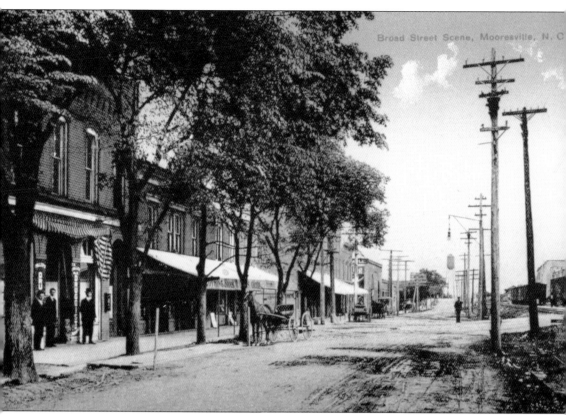

"BROAD STREET SCENE," 1890s. This postcard shows Broad Street looking north with Main Street and the railroad tracks on the right. The building at left with the men standing on the sidewalk is the Goodman Drug Company before it moved to Main Street after the turn of the century. The road to the right crossing the railroad tracks is Center Avenue. The water tower in the background was used for the flour mill. Note the buggies parked along the street as well as the man in what may be a uniform standing along what appears to be a stand on the side of the street.

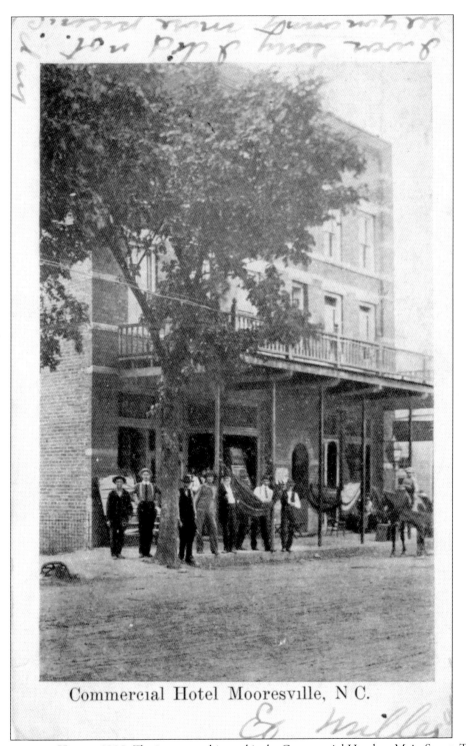

Commercial Hotel Mooresville, N C.

COMMERCIAL HOTEL, 1908. The image on this card is the Commercial Hotel on Main Street. The photograph is thought to have been taken around the opening of the hotel, as indicated by the large banner strung between the columns.

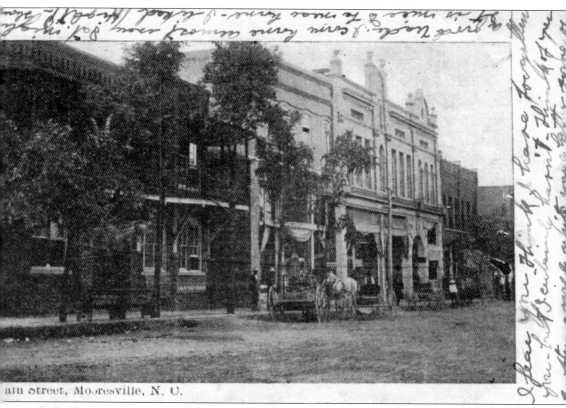

ain Street, Mooresville, N. C.

D.E. TURNER HARDWARE BUILDINGS, C. 1900. At the turn of the 20th century, photographic postcards became popular in Mooresville, showing the buildings along Main Street; this postcard is a good example. Showing the Central Hotel and D.E. Hardware with Goodman Drug at the end of the block, this photograph was possibly taken shortly after Turner and First National Bank added their new buildings next to Goodman's store. Note the carriages along the street in front of the buildings. Turner used to make and sell carriages and wagons in his store.

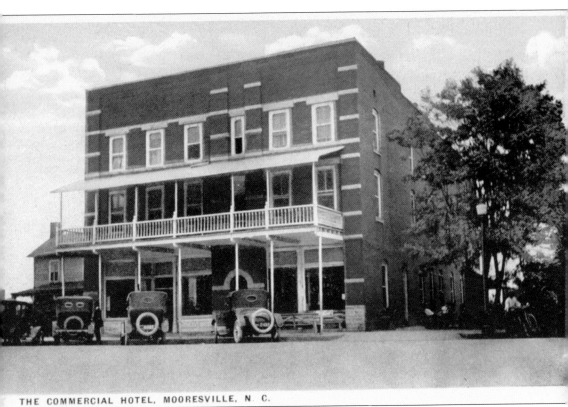

THE COMMERCIAL HOTEL, MOORESVILLE, N. C.

COMMERCIAL HOTEL ON MAIN STREET, 1920S. The largest of the two hotels in town, the Commercial Hotel housed a café and other businesses on the ground floor. Note the men on the right as well as the young man with the bicycle under the tree. The home to the left of the hotel shows the types of houses that were once along Main Street. The hotel stood until 1963, when it was torn down.

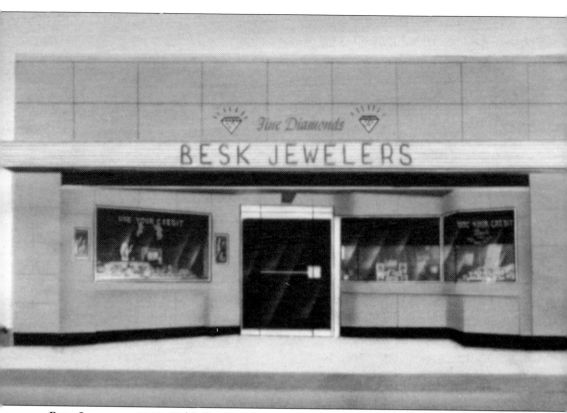

BESK JEWELERS, 1930–1945. This jewelry store was once at 169 North Main Street. This image shows the post–World War II style that was popular at the time, with the large plate-glass windows and a large glass front door. Note the "Fine Diamonds" at the top and the credit notices on the windows. (Courtesy of North Carolina Collection Photographic Archives, Wilson Library, UNC-Chapel Hill.)

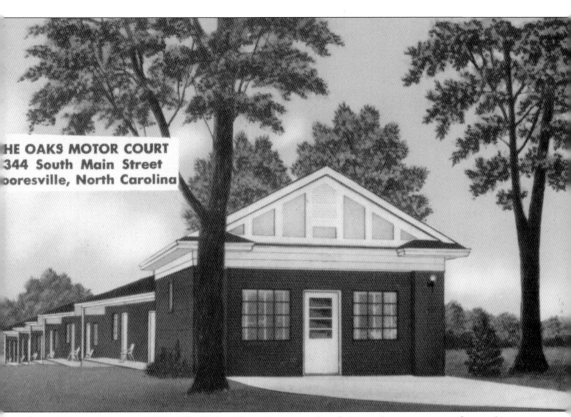

THE OAKS MOTOR COURT
344 South Main Street
Mooresville, North Carolina

OAKS MOTOR COURT, 1950s. The Oaks Motor Court on South Main Street was one of several new motels built in Mooresville in the mid-20th century. The building was erected with the main office as the front building and the rooms in wings that extended from the main building. This allowed for a larger parking area within the L-shape formed by the buildings.

THE OAKS MOTOR COURT

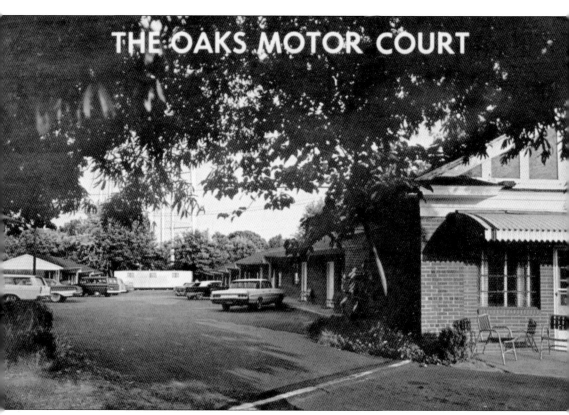

OAKS MOTOR COURT ON MAIN STREET, 1980S. This postcard was sent by Bill and Hazel Sprinkle, the owners of the court, to friends. They asked if all were okay and shared that they had arrived home with Hazel under the doctor's care; however, they had a wonderful time. The motor court was one of several hotels in town built before Interstate 77.

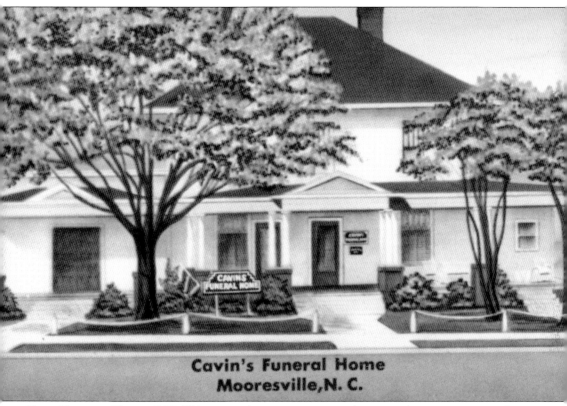

Cavin's Funeral Home
Mooresville, N. C.

CAVIN FUNERAL HOME, 1955. This postcard was sent as a reminder notice that a payment was due on the recipient's account. Not all postcards were written by or used for those visiting the town to write home. Many businesses then, as today, sent out cards as reminders for appointments, account issues, and sales.

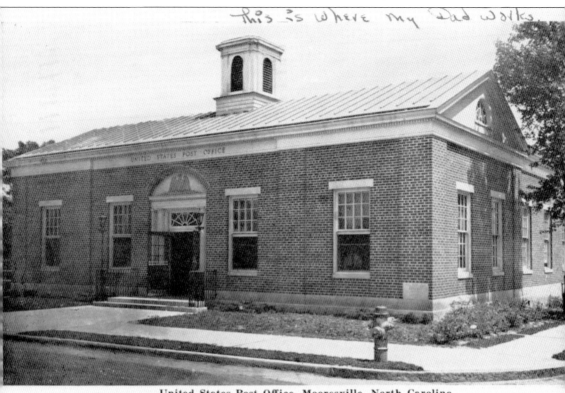

This is where my Dad works.

United States Post Office, Mooresville, North Carolina

Post Office, 1947. Built in the 1930s at the corner of Main Street and Iredell Avenue as part of the federal Works Progress Administration (WPA), this building served as the post office until the 1960s, when it moved to Institute Street. Today, this building houses the central offices for the Mooresville Graded School system. Inside, the lobby and postmaster's office have been preserved in their original condition. This was the largest of the WPA projects in the town. This card was sent to Davis Hicks in Baltimore from Rena Lau, who wrote to say that she was sorry Miss Hicks could not come, and that they were going to the mountains and she needed to decide about a Christmas gift. On the front, she wrote that this was where her dad worked.

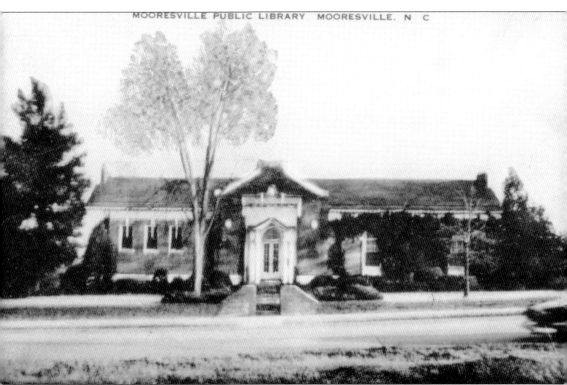

MOORESVILLE PUBLIC LIBRARY, 1939. This postcard shows the library shortly after its completion. The building was erected by LuTelle Sherrill Williams on her homesite and was gifted to the Town of Mooresville. The Neoclassical structure was built with brick, steel, and concrete walls in order to make it fireproof. Inside are vaulted ceilings, Art Deco lighting, and tiger oak furniture and bookcases. Today, this original building houses the Local History & Archives Department.

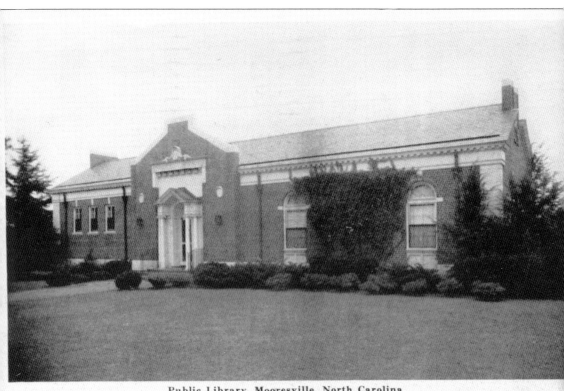

Public Library, Mooresville, North Carolina

LIBRARY, 1940S. This postcard of the library building faces north on Main Street and shows the ivy that once covered the building. It was expanded in the early 1960s to include a children's room and a larger basement for storage. In 2005, the building expanded again when a new 30,000-square-foot addition was constructed, allowing for much-needed additional room, as the library had outgrown the smaller building. Today, the library still occupies this and the newer building as it continues to serve the community.

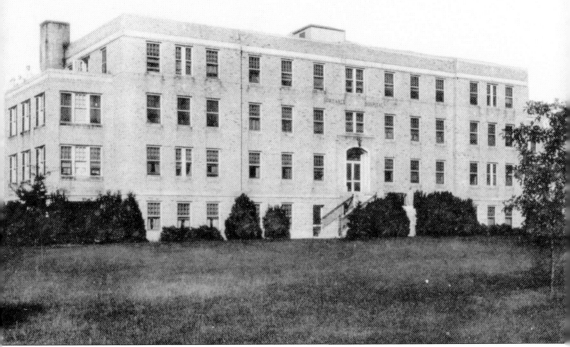

LOWRANCE HOSPITAL, 1920s. This postcard shows the second building for Lowrance Hospital. This was the original building before it was expanded and a stucco facade added. The front door is in the center at the top of the stairs, and the nurses' balcony is at top left at the end of the surgical floor. The hospital was built at the highest point in Mooresville and served for a time as a fire watch point.

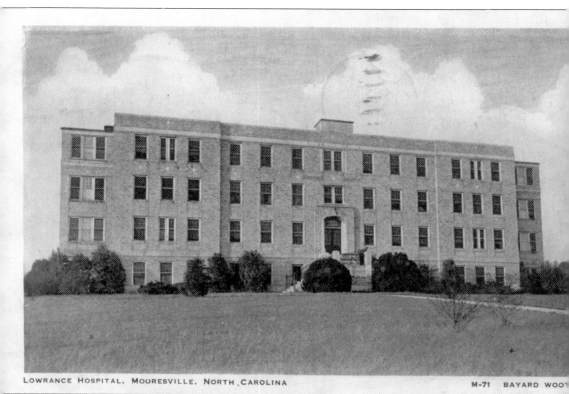

LOWRANCE HOSPITAL, MOORESVILLE, NORTH CAROLINA M-71 BAYARD WOO

LOWRANCE HOSPITAL, 1940s. This postcard shows the second building of Lowrance Hospital. It was located at Statesville and East Center Avenues after its move from West Center Avenue. The new, larger facility could offer more services to the citizens of Mooresville. Not seen in this image is the expansion of the hospital that was done post–World War II, when the first wing was added, increasing the number of rooms, offices, and surgical areas.

Three

CHURCHES, MILLS, AND CENTRAL HIGH SCHOOL

Some of the favorite subjects of early postcards were churches, schools, and industrial buildings. By the 1890s, a new construction boom in town saw the creation of several new mills, the expansion of several churches, and a new school. One church that was expanded was First Presbyterian.

Originally built in 1875, by 1899, the congregation had outgrown the original building. By 1900, the church had purchased land on Academy Street to construct a new redbrick building. In the American Gothic style with high arched windows, tall bell towers, and cast-iron finials with Scottish crosses along the roof line, it was the largest non-commercial building in the town. Built on an open lot, the church was ideal for photographing, as all sides of the building could be seen, offering a variety of interesting perspectives.

Another building of photographic interest was the second Central Methodist Church, built in the same American Gothic style with high-arched windows, a bell tower, granite-block window seals, and dark-red brick. Unlike the First Presbyterian Church, however, it was rarely photographed by itself. In 1906, the new Central School building was erected in the same style across from the church. With three stories of Gothic windows, arched doorways, and the same red brick, the building was often photographed alongside the church.

In addition to the churches and the school, the mill buildings were also depicted on postcards. While not as impressive or as decorative, these buildings generated interest if not for their style, perhaps for their enormous size. Built on a scale that dwarfed the other buildings in town with large, square windows and "layers" of buildings appearing to be stacked on top of each other, these structures showcased the industrial side of Mooresville.

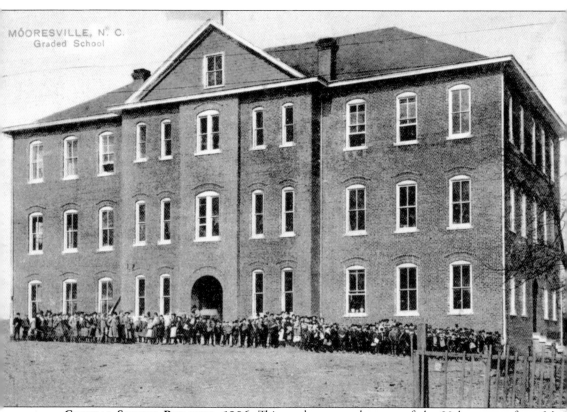

CENTRAL SCHOOL BUILDING, 1906. This card, sent at the turn of the 20th century from M. McNeely to Fred Hubbard in Wilkesboro, shows the Central School with all the staff and students lined up in front. The school was the second largest non-commercial brick building in town.

CENTRAL SCHOOL, 1906. This is one of the few early examples of students in Mooresville writing to friends and possibly other students. The message on the back is a simple one that reads, "I wonder what part you take in the band. I'm looking forward to hearing you all play sometime. Our school is out today. Everybody who could has had measles during the past four weeks, so we are not going to have any concert. I wish so much that I could go to Wilkesboro next week, but I can't. M. McNeely."

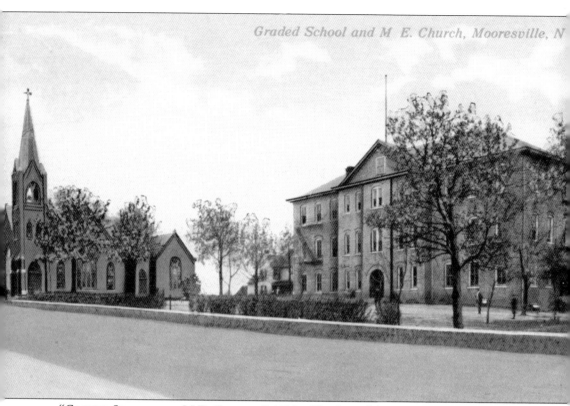

"GRADED SCHOOL AND M.E. CHURCH," 1900s. The date of this postcard is not known, but the message indicates that the sender was having fun, going to lots of picnics, and was in love with the place. The front of the card shows the Central Methodist Church and the Central School building. While pictured on the same side of the street, the two were actually across the street from each another. It is thought that the image was meant to show the architectural styles of the two structures. The building for the church is the second one, constructed in the early 1900s.

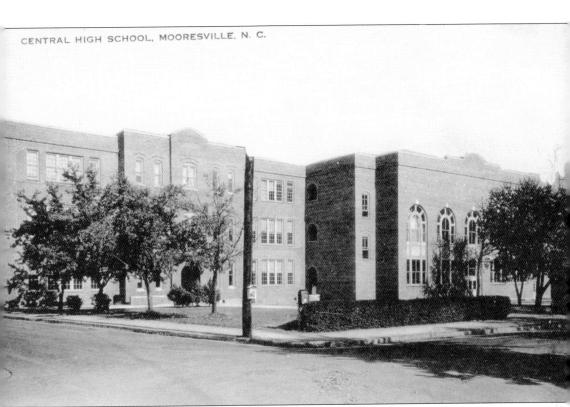

CENTRAL HIGH SCHOOL, MOORESVILLE, 1948. This postcard shows Central High School with the addition of the auditorium to the right. The top floor of the school was rebuilt after a fire. The building housed 1st through 12th grades until the 1940s, when two elementary schools were added for 1st through 5th grades. In the early 1950s, the junior high school was built for 6th and 7th grades, leaving grades 9–12 in the high school.

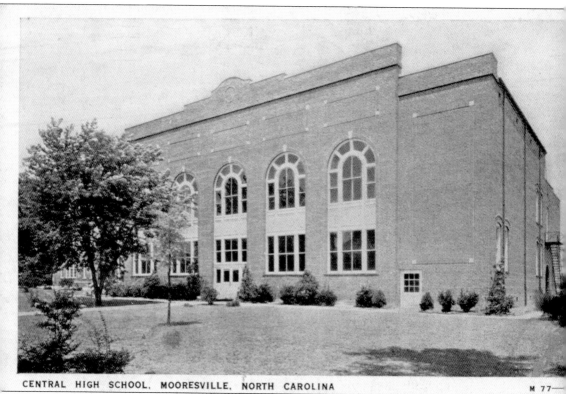

CENTRAL HIGH SCHOOL, MOORESVILLE, NORTH CAROLINA M 77

CENTRAL HIGH SCHOOL AUDITORIUM, 1940s. This postcard shows the auditorium of Central High School. The new auditorium was built after a fire in the 1920s destroyed the old auditorium, which had been in the top floor of the building. The new auditorium was larger with more seating and a bigger stage, as well as fireproof.

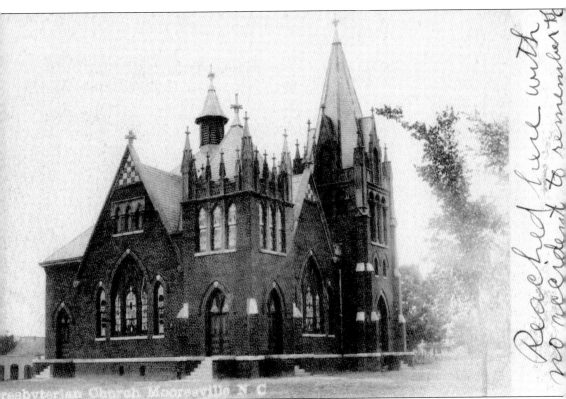

First Presbyterian Church, 1900. This postcard, postmarked 1907, was produced a few years after the completion of the new First Presbyterian Church. The new structure was the second largest non-commercial building in town with a sanctuary that could seat 200. The finials on top of the steeples and roof line were made of cast iron made at the Troutman (later Mooresville) Iron Works. The window sills and capstones on the corner buttresses of the two towers are granite blocks from Granite Quarry, North Carolina. Note the message written along the edge, "Reached here with no accident to remember."

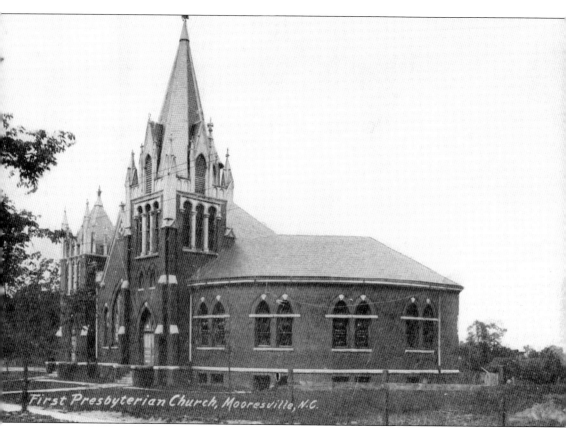

First Presbyterian Church, Mooresville, N.C.

FIRST PRESBYTERIAN CHURCH AND PARLOR, 1917. This postcard shows the other side of the new First Presbyterian Church. The building, which was to be in the design of a Celtic cross, was never finished. This photograph shows the side that was used for classrooms and Sunday school. There was a large set of pocket doors that opened to the main section of the building so that the space could be used as part of the sanctuary. Just behind it, an outhouse and a hitching rail for horses can be seen.

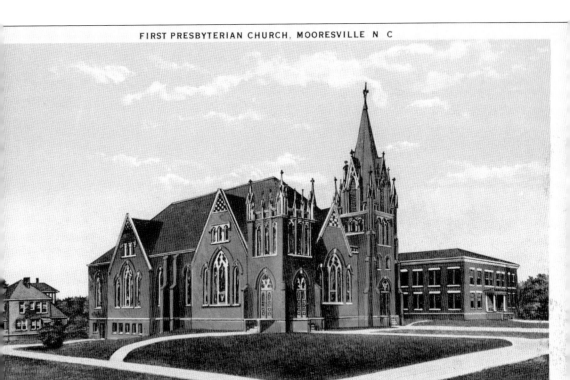

MANSE, JANUARY 1922 NEW SUNDAY SCHOOL BUILDING, DECEMBER, 1922

FIRST PRESBYTERIAN CHURCH CAMPUS, 1920S. This postcard shows the First Presbyterian Church with the manse, educational building, and new addition to the sanctuary. Along with the name of the educational building, the dates on the card are not correct. The manse was built in 1922, the educational building in 1924 (noted incorrectly on the card), and the new expansion of the sanctuary in 1925. The expansion can be seen, as can the addition to the back of the church, starting at the two buttresses. The project was completed under Rev. Robert Ashlin White, who preached the shortest service in 1930 when the bank wanted to call in the loan. A prayer was said, a hymn was sung, and the rest of the day was spent fundraising.

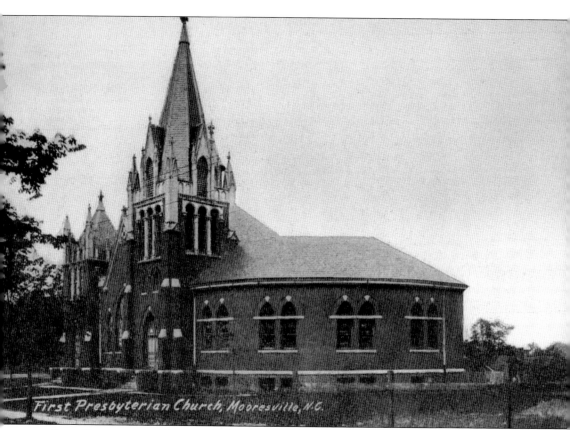

First Presbyterian Church, Mooresville, N.C.

FIRST PRESBYTERIAN CHURCH BUILDING, 1911. This postcard shows the other side of the First Presbyterian Church and is postmarked 1911. The postcard is thought to be one of the earliest known correspondences between two local school-age children. The sender wrote about school, Carry saying hello, someone getting scolded, and the yardstick.

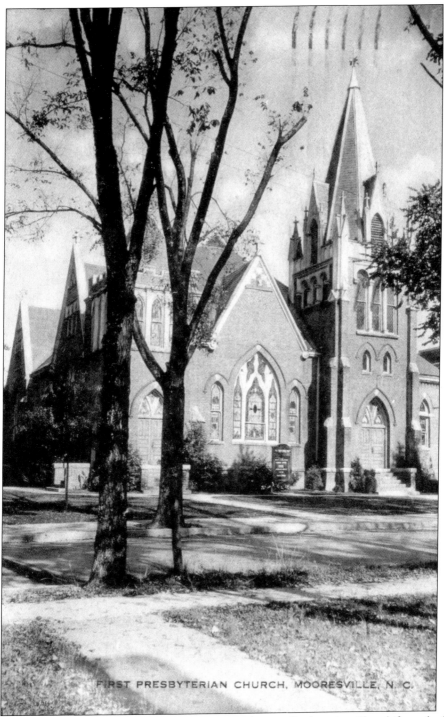

FIRST PRESBYTERIAN CHURCH, MOORESVILLE, N. C.

FIRST PRESBYTERIAN CHURCH TOWERS, 1937. This is the First Presbyterian Church from the front with the new expansion. Note the Gothic windows with a checkerboard pattern in the tops of the eaves, as well as the crosses on the roof points. The windows were made by the C.S. Laws stained glass company in Statesville.

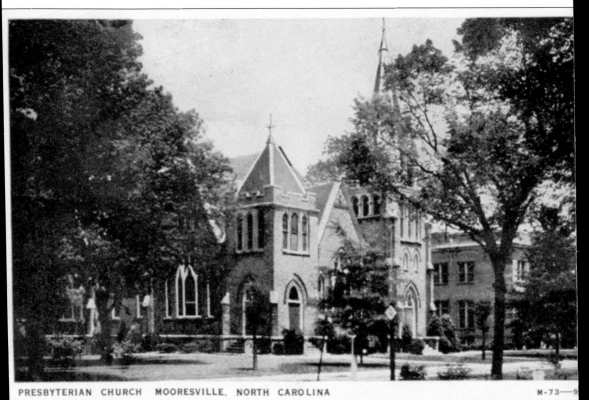

PRESBYTERIAN CHURCH MOORESVILLE, NORTH CAROLINA M-73—9

FIRST PRESBYTERIAN CHURCH AND EDUCATIONAL BUILDING, 1946. This postcard was sent to the workers of the Biscayne Engineering Company in Miami, Florida. The image on the front is of the First Presbyterian Church. The church was organized in 1875, and this building was erected in 1900. It was the second largest non-commercial structure in town, and after a 1925 expansion, could hold 500 people in its sanctuary. The structure to the right is the first educational building, erected in 1923. The slate roof is accented by iron crosses that were made in the Troutman Iron Works, which became Mooresville Iron Works, and later, Compton Knowles.

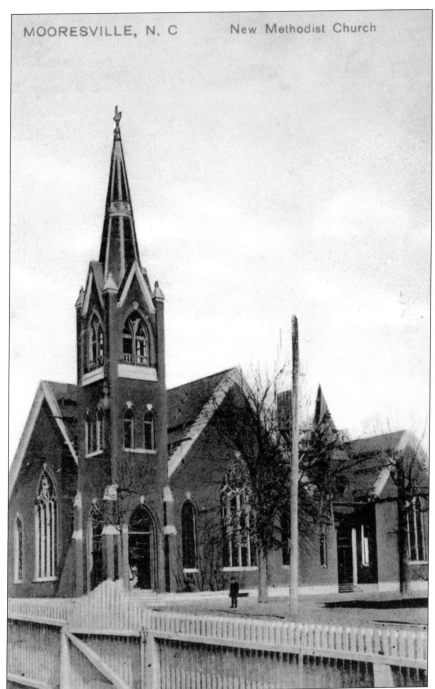

NEW METHODIST CHURCH, MOORESVILLE, 1908. This postcard is the second building of the Central United Methodist Church. Erected in the early 1900s, this structure stood on the corner opposite the first building. The building was constructed in the same style as the First Presbyterian Church and is thought to have been designed by the same architect. The photograph was taken from what is thought to be the front yard of the Central School building, which was across the street on the opposite corner. The message on the back discusses family matters and travel.

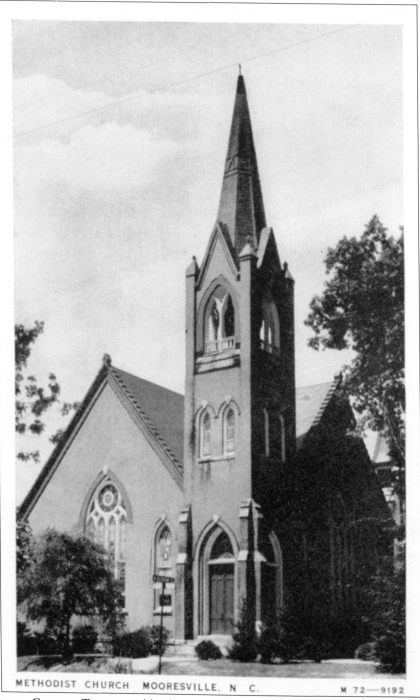

METHODIST CHURCH MOORESVILLE. N. C. M 72——9192

METHODIST CHURCH TOWER, 1944. This postcard shows the main entrance and tower of the second building of Central Methodist Church organized in 1877; in 1907, the cornerstone for a new structure on the corner was laid beside the old building. The new structure was finished in 1908. The style of the building is the same as the First Presbyterian Church; note the rose windows at the top of the Gothic-style lower ones.

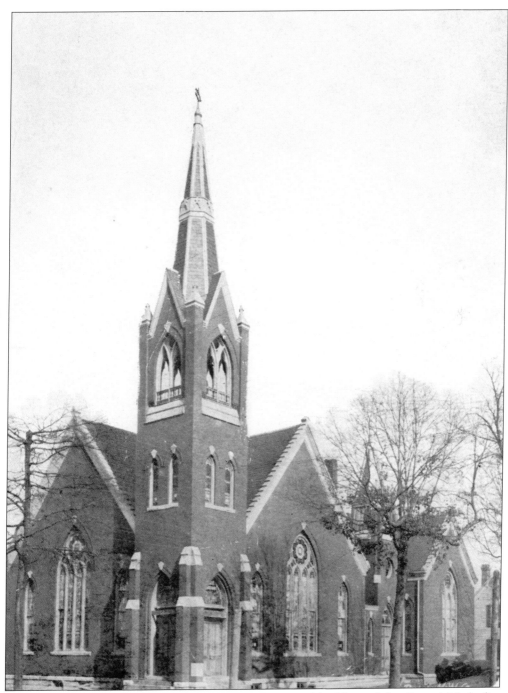

CENTRAL METHODIST CHURCH, 1913. This is the second building of the Central Methodist Church with a part of the manse in the background. The image shows the main double entrance under the bell tower as well as the middle entrance. The card, written after a night out, asks how the receiver, Myrtle Lawson, is doing the day after. Today, one might make a text or phone call to inquire about someone after a night out, but in 1913, it was cheaper—though not faster—to send a postcard.

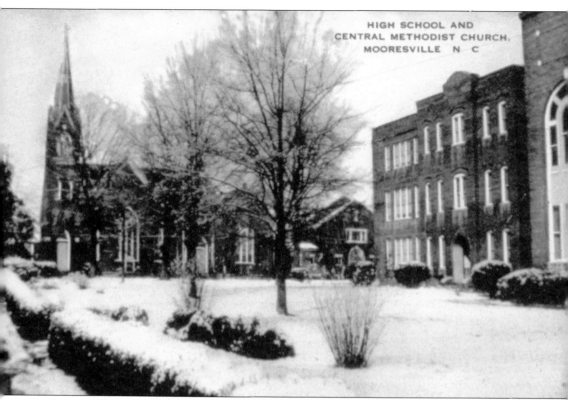

HIGH SCHOOL AND
CENTRAL METHODIST CHURCH.
MOORESVILLE N C

CENTRAL HIGH SCHOOL AND CENTRAL METHODIST CHURCH, 1940s. This postcard shows both the Central Methodist Church and the Central High School building together. While the buildings were on opposite sides of the street, they were often pictured together. The Central Methodist congregation was instrumental in education in Mooresville, having first started the Oak Institute school, and later Central School, now the Mooresville Graded School System. In 1966, the church built its third and current property. This postcard, however, is noteworthy because it shows a feature of Mooresville that many do not think happens—snow.

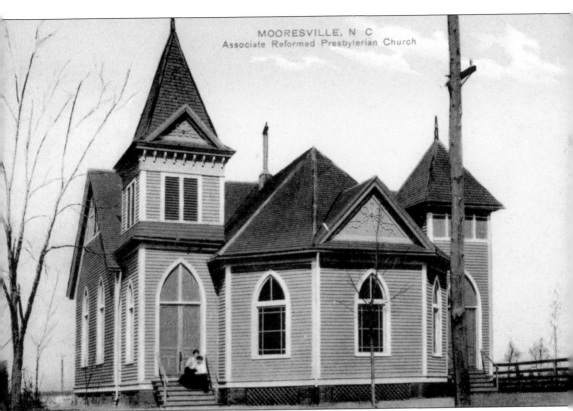

ASSOCIATE REFORMED PRESBYTERIAN CHURCH, C. 1900. The Associate Reformed Presbyterian Church of Mooresville was organized in 1885 and met in the Oak Institute School until it was dissolved. In 1896, the church was reorganized, and in 1898, purchased a lot at 327 North Main Street, where it erected a wooden-frame building. By the mid-20th century, the church needed a larger home, and with a gift from John Flood Matheson and Mary Elizabeth Davidson Matheson, it relocated in 1950 to its current home on Carpenter Avenue. By 1955, a new sanctuary had been constructed.

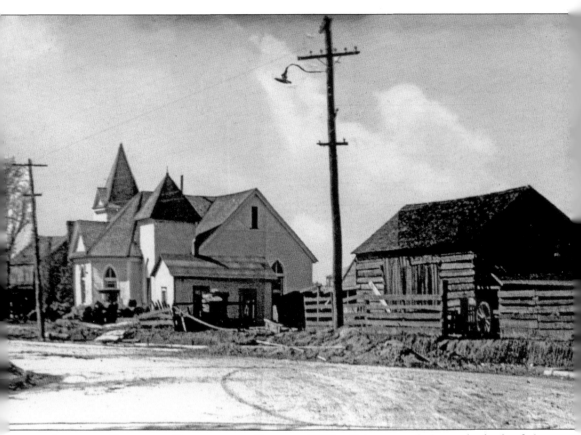

Associate Reformed Presbyterian Church, 1920s. This postcard shows the back of the Associate Reformed Presbyterian Church. Note the dirt street, the electric streetlight, and the barn and wagon just down Main Street from the church. Many of the houses in town had barns on their property until the mid-20th century, when people no longer had a need to keep livestock. The small building beside the church is possibly the old session house or a school and shows two doorways. The smaller wooden structures beside the smaller building are thought to be the outhouses for the church.

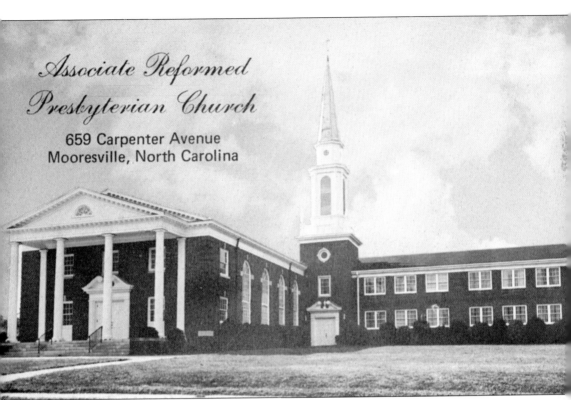

Associate Reformed Presbyterian Church

659 Carpenter Avenue
Mooresville, North Carolina

ASSOCIATE REFORMED PRESBYTERIAN CHURCH, 1960S. This photograph was taken sometime after the church moved from Main Street to its present location on Carpenter Avenue. The new church had a larger sanctuary as well as a new educational building. Both were constructed off a central tower that stood at the axis of the two buildings. The first part of the structure (the educational building) was erected in 1950, with the sanctuary built in 1955.

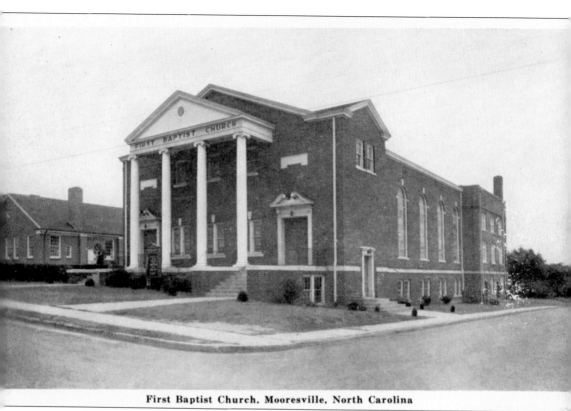

First Baptist Church, Mooresville, North Carolina

FIRST BAPTIST CHURCH, 1950s. The First Baptist Church was organized in 1882 in a building at the corner of South Academy and Kelly Streets; today, it is a private home. In 1902, the church moved into the old wood-frame building of the First Presbyterian Church on its current site, which had been built in 1875. In July 1933, the wooden-frame building caught fire and burned to the ground. The church quickly started fundraising for a new building, and on July 26, 1936, started the sanctuary fund. In 1938, the current structure was built. In 1957, as seen in this postcard, the old front of the church was remodeled, and again in 2001.

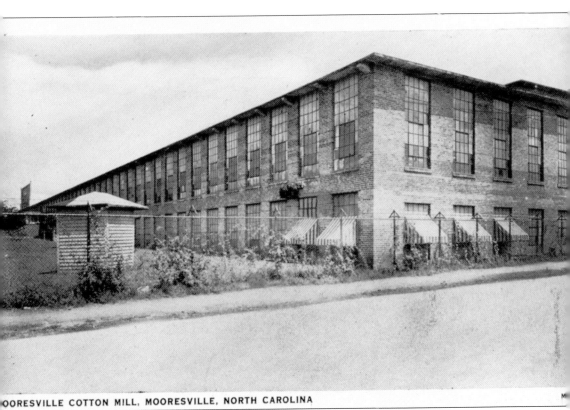

MOORESVILLE COTTON MILL, MOORESVILLE, NORTH CAROLINA

MOORESVILLE COTTON MILL, 1930s. This is the Mooresville Cotton Mill on South Main Street. The image looks from the end of the property north up the street. The first part of this building was erected in the early 1900s. It was expanded to include five other buildings in the complex by the mid-20th century. To the right of the building, just outside the frame, were the train tracks that ran through the middle of the complex. At their height, the structures covered over a million square feet under roofs.

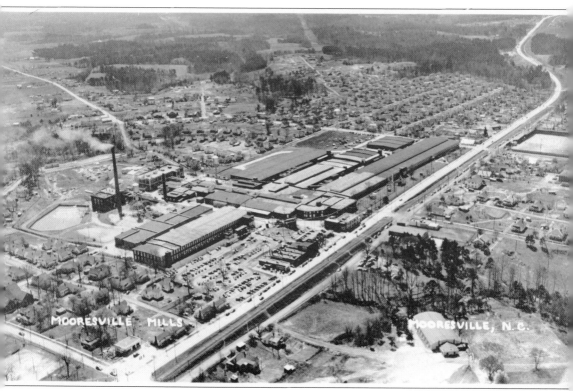

MOORESVILLE MILLS, 1940s. This is an aerial photograph of the Mooresville Cotton Mill complex on South Main street. The image was taken in the 1940s when the complex was half of its final size. In the background is the mill village that surrounded the mill. During World War II, the mill had several government contracts, one of which was for making fabric for parachutes. At upper right is the baseball field for the Mooresville Moors.

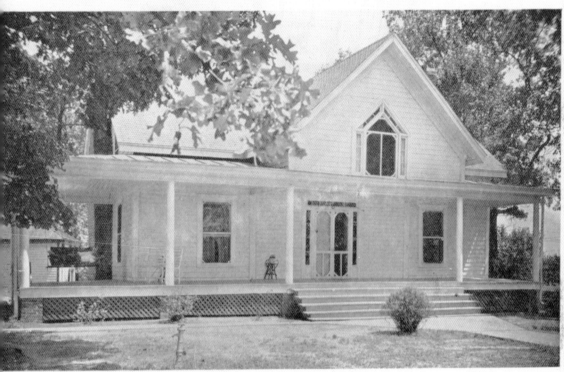

M-80

COMMUNITY HOUSE, 1930S. This postcard shows the community house for Mooresville Cotton Mill. The house, built around the turn of the 20th century, was first home to Dr. George Taylor when he came to Mooresville in 1912. Dr. Taylor was one of the directors of the Mooresville Cotton Mill, and when he constructed his new home on East Center Avenue near the new Lowrance Hospital in the 1920s, his former house became part of the mill. The house was used for picnics, gatherings, special events, and as a nursery for the children of mill employees.

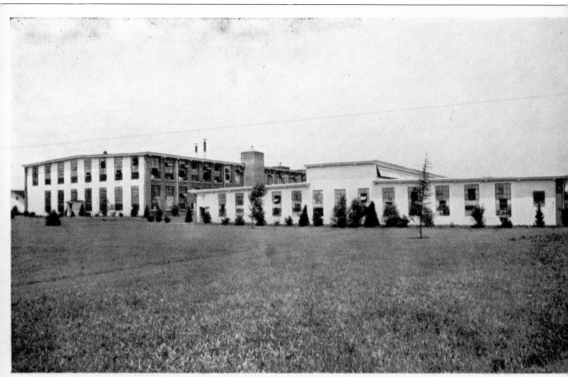

CASCADE MILL, MOORESVILLE, NORTH CAROLINA

CASCADE MILL, 1950s. This is the Cascade Mill in the mid-20th century. The mill was originally the Dixie Cotton mill, which was started in 1906 by Espy Brawley on his property. The plant processed cotton grown on his farm. It operated until the early 1930s, when it closed due to the Great Depression. In 1934, Burlington Industries purchased the plant and opened it as Cascade Weaving Company. The mill was remodeled to make it more modern. It operated until the 1990s, when Burlington Industries closed its Mooresville plants.

Four

THE LAKE

By the mid-20th century, a new addition was created in the Mooresville community known as Lake Norman. The lake brought a new era of postcards that featured many of the sports, activities, and sites associated with the lake. The lake, as the largest man-made lake in North Carolina, brought with it new tourists coming to spend time for vacations, which in turn created new businesses related to the tourist industry. The lake was the third boom in Mooresville's growth and has had the longest and largest impact on the community as a whole.

Duke Power began purchasing land for Lake Norman in the 1920s as part of the long-range plan for a chain of hydroelectric plants along the Catawba River. Lake Norman was to be the largest in the chain and thus able to support more than one power plant, allowing Duke Power to serve a larger population. The site of the new dam was at a historic point along the Catawba River where the river narrowed across a bedrock formation that originally served as a safe passageway for early travelers known as Cowans Ford. Over the years, communities and farms had grown up around the ford and the soon-to-be lake area.

In 1960, Duke Power broke ground on the Cowans Ford dam, ushering in the start of the newest hydroelectrical power plant and the creation of Lake Norman. The lake originally supplied water to Cowans Ford Hydro-Electrical station and Marshall Steam Station, and later McGuire Nuclear Station. The new lake, with 500 miles of shoreline, would be the largest manmade body of water in the state.

The lake had a major economic and historical impact on Mooresville that would change the landscape for years to come with new businesses and tourists, all of which were recorded with postcards.

The scenery is beautiful at

MOORESVILLE, N.C.

The place where YOU ought to be

SUNSET IN MOORESVILLE. This postcard shows the sun setting over the lake. The right side promotes the town. This is an example of some of the tourist cards that were produced in the mid-20th century and of the early start of the tourist trade that was to be built around the lake.

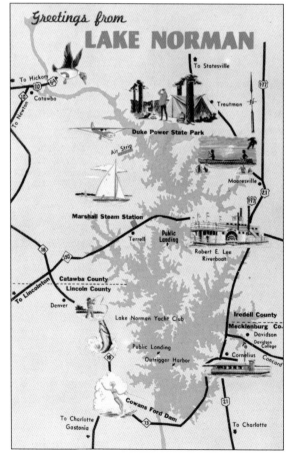

LAKE NORMAN, 1960s. This postcard shows a map of Lake Norman, along with various attractions, major roads, and towns. It was designed to show the tourist attractions at the lake, including camping sites and public landings, as well as the *Robert E. Lee* river boat.

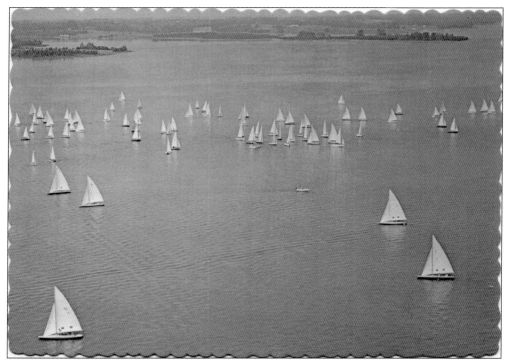

"SAIL BOATING ON LAKE NORMAN." This undated postcard shows one of the more popular pastimes on Lake Norman: sailing. Since the formation of the lake, many people have enjoyed sailing on the water. Over the years, various sailing clubs, yacht clubs, and others have formed. Some of the clubs hold popular regattas each year.

SAIL BOATING on LAKE NORMAN
White sails, blue waters and a good breeze insure boating pleasure on North Carolina's largest inland body of water, Lake Norman.

Pub. by Aerial Photography Services, Inc., 2300 Dunavant St., Charlotte, N.C. 28203

7271-C

post card

© Aerial Photography Services, Inc., Charlotte, N.C.

dp MADE BY DEXTER PRESS WEST NYACK, NEW YORK

SpCP 383.0037

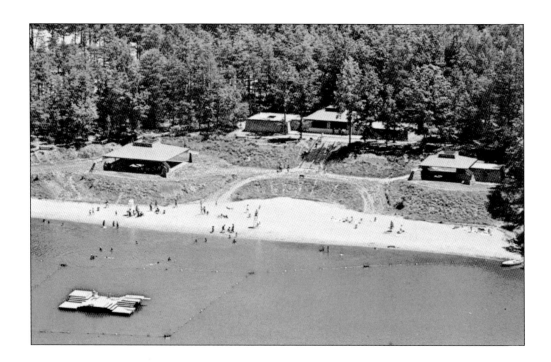

DUKE POWER STATE PARK. This is Duke Power State Park on Lake Norman. In the early days of the lake, Duke Power partnered with the state of North Carolina to create several public parks; land was set aside for the use of the public so that all had a chance to enjoy the lake. This card shows the first park created by Duke Power, which is still in use today. The back of the card provides a bit of information on all that is offered at the park.

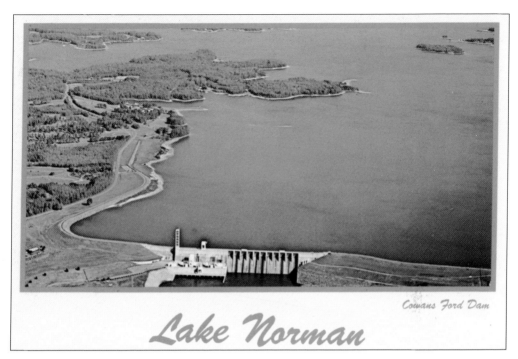

Cowans Ford Dam

Lake Norman

COWANS FORD DAM AND LAKE NORMAN, 1960S. This postcard shows Lake Norman and Cowans Ford Dam. The dam was started in 1960 and completed a year later. The site was formerly known as Cowans Ford and was the site of a Revolutionary War battle between Gen. William Davidson and General Cornwallis. The ford was shallow with large granite stones, which made crossing the river easy without the need of a ferry. The site was also the narrowest point on the river, which was ideal for the dam. The dam supplies water to the Cowans Ford Hydroelectric power plant.

LAKE NORMAN

Largest man-made lake in North Carolina 32,510 acres with 520 miles of shore line. The concrete dam is 1,279 feet long with 11 flood gates and a total length of 7,387 feet of earth and concrete dams. Lake Norman offers excellent fishing, boating and swimming more variety to North Carolina s Variety Vacationland.

Pub. by Aerial Photography Services, Municipal Airport Branch, Charlotte, N. C.

PLACE STAMP HERE

Post Card

© 1966 Aerial Photography Services
20689-C

MADE BY
DEXTER PRESS, INC.
WEST NYACK, NEW YORK

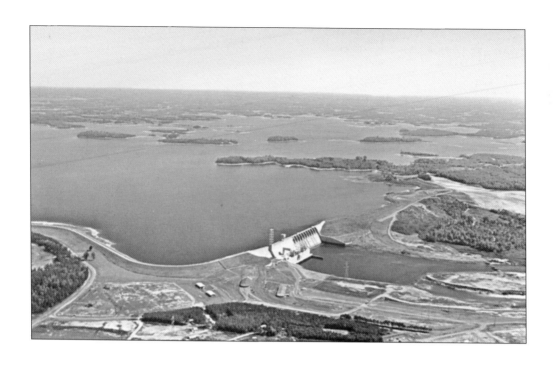

"THE INLAND SEA," 1960S. This postcard shows the Cowans Ford Dam and the surrounding earthen dams. The dams are part of a system of earth and concrete that make up the whole dam. The islands in the lake are the tops of hills that once surrounded the river.

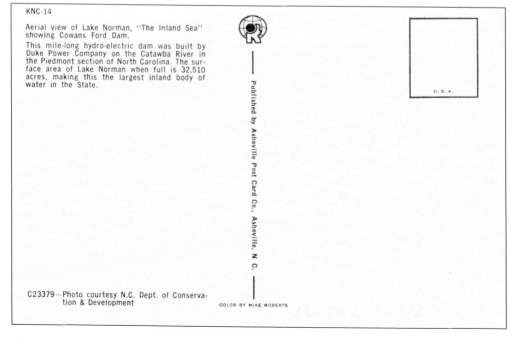

KNC-14

Aerial view of Lake Norman, "The Inland Sea" showing Cowans Ford Dam.

This mile-long hydro-electric dam was built by Duke Power Company on the Catawba River in the Piedmont section of North Carolina. The surface area of Lake Norman when full is 32,510 acres, making this the largest inland body of water in the State.

Published by Asheville Post Card Co., Asheville, N. C.

U. S. A.

C23379—Photo courtesy N.C. Dept. of Conservation & Development

COLOR BY MIKE ROBERTS

DUKE POWER COWANS FORD DAM, 1970s. Noted on the back of this postcard is the length of the dam, the acres of the lake, and some of the features of the dam.

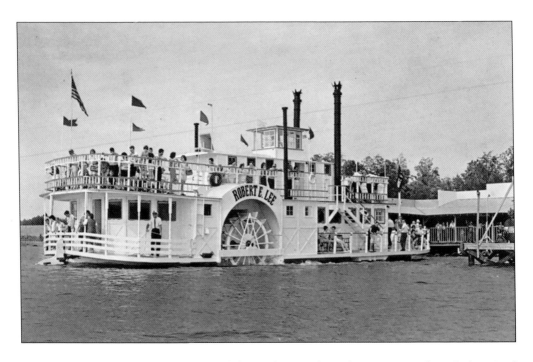

ROBERT E. LEE RIVERBOAT, 1960S. Built by Buff Grier, the *Robert E. Lee* was launched in April 1964. The 84-foot sidewheeler was a steam-powered replica of an original riverboat. The *Robert E. Lee* cruised the waters of Lake Norman carrying people and tour groups for sightseeing and holding parties for local businesses and clubs. The boat was in service until January 5, 1966, when it caught fire and burned at its dock off Alcove Road. On the back of the postcards were little bits of the history of the boat that differed with each card.

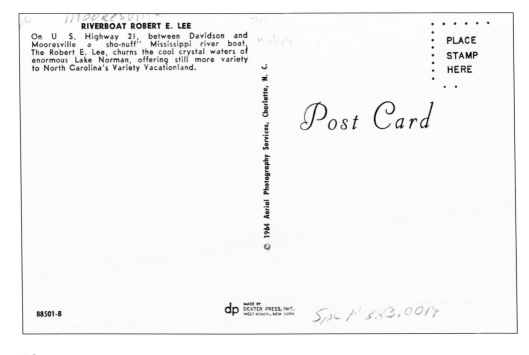

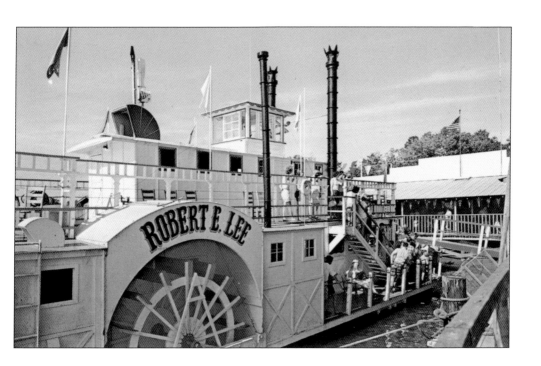

Riverboat Robert E. Lee, 1960s. This postcard shows a close-up side view of the riverboat with passengers. The sidewheel paddleboat was driven by steam power to offer an authentic Mississippi riverboat ride on the lake.

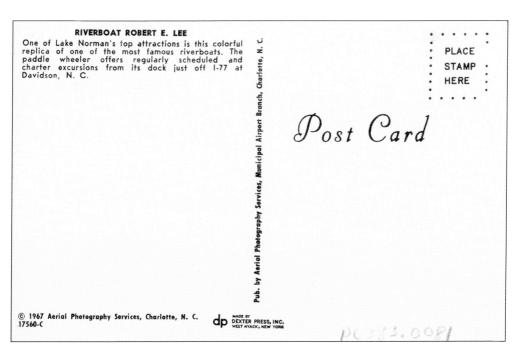

RIVERBOAT ROBERT E. LEE

One of Lake Norman's top attractions is this colorful replica of one of the most famous riverboats. The paddle wheeler offers regularly scheduled and charter excursions from its dock just off I-77 at Davidson, N. C.

Pub. by Aerial Photography Services, Municipal Airport Branch, Charlotte, N. C.

PLACE STAMP HERE

Post Card

© 1967 Aerial Photography Services, Charlotte, N. C.
17560-C

dp MADE BY
DEXTER PRESS, INC.
WEST NYACK, NEW YORK

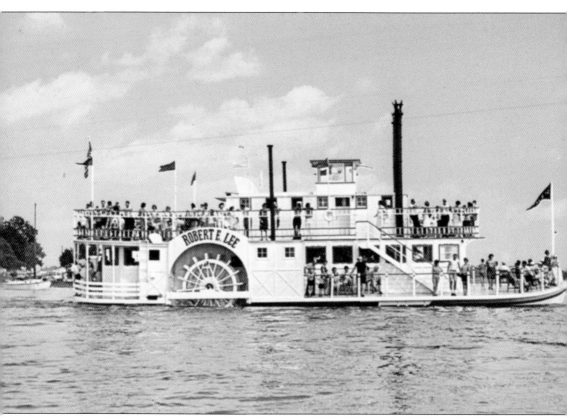

ROBERT E. LEE RIVERBOAT ON LAKE NORMAN, 1960s. This postcard shows the *Robert E. Lee* on Lake Norman. The photograph was taken as the boat was pulling away from its dock, loaded with a new group of passengers. The boat traveled around a portion of the lake taking people and groups on sightseeing tours of the lake and surrounding countryside.

Five

Beyond Mooresville

By the mid-20th century, postcards of Mooresville had grown past the business district to other areas. Featured images began including the new post office erected as part of the WPA, Cavin's funeral home, the community house, and the Oaks Travel Lodge. Some postcards even featured businesses along the growing Highway 150 corridor; the main focus now shifted from the downtown area and the popularity that came from people visiting the town.

Today, postcards have taken on a different meaning as many of the older, original cards have been reprinted. Postcards showing places like the depot or the State Theater have been reproduced, fueling a new market of tourists, newcomers, and a younger generation who want to know more about the town's history. People have been interested in seeing images of Main Street before it was paved, the hotels and theaters that once lined the downtown, and even the mills as they once looked at the height of their operation, all captured on a postcard.

In addition, as genealogical research grows in popularity and more and more people become interested in learning about their past, postcards have started to become a part of their research. The notes and messages penned on the backs of many postcards contain rare and often important genealogical information that cannot be found in other resources. Notes about grandma's health, dad feeling better, or aunt Jane and mother coming up on the afternoon train are small nuggets of information that fill gaps in many genealogical records.

Whether it is schoolchildren writing to overseas pen pals or newcomers to town or someone researching their genealogy, postcards remain a part of the history of Mooresville. While today there are fewer postcards than in the past, their importance in the overall history of Mooresville is as important as those penned over a century ago. The question now is what will be told about Mooresville in the next 100 years.

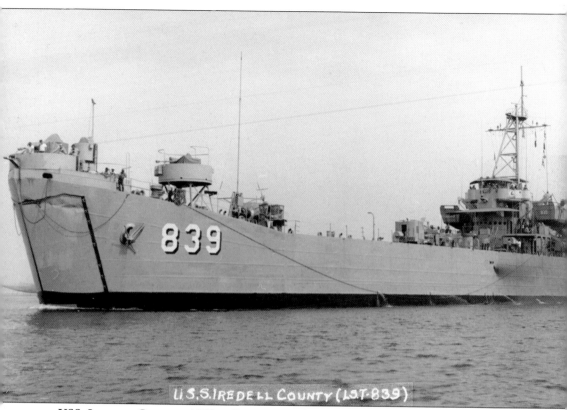

U.S.S. IREDELL COUNTY (LST-839)

USS IREDELL COUNTY, 1950S. Commissioned on December 6, 1944, as LST-839 in New Orleans, the ship served in World War II, receiving several commendations and medals. She was decommissioned on July 24, 1946, and was sent to a naval yard, where she stayed until she was recommissioned on July 1, 1955, as the USS *Iredell County*. She went on to serve in Vietnam, where she again won commendations and medals. She was finally decommissioned in July 1970 and sold to Indonesia in February 1979. This is an example of the postcards that service men and women from Iredell would have sent home to loved ones and family.

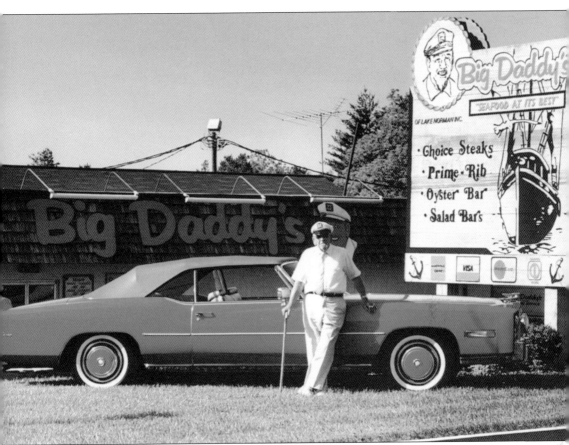

BIG DADDY'S, 1994. This postcard from around 1994 shows a popular restaurant on Highway 150. Started in Kure Beach, this location of Big Daddy's opened in 1974. Offering seafood and steaks, the restaurant has been a popular destination for decades. In the mid-1990s, it was remodeled, and the original façade seen here was changed to the current one. This is an example of later postcards that feature business and tourist spots outside of the town.

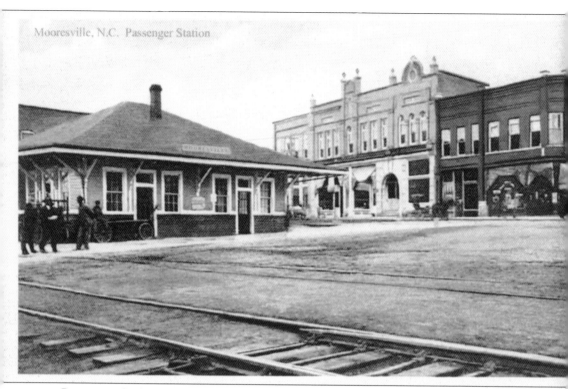

Mooresville, N.C. Passenger Station

PASSENGER STATION, 1900s. This postcard from the 2000s is a reprint of an earlier card showing the same scene of the second depot and Main Street. After the turn of the 21st century, businesses began to reissue postcards of older scenes as a way of to show tourists and newcomers some of the buildings and places that were once in Mooresville. Some of the newer cards were of new places or locations in town that highlighted industries as well as attractions. While not as popular as they once were, postcards are still used for short messages to friends and family or simply as souvenirs.

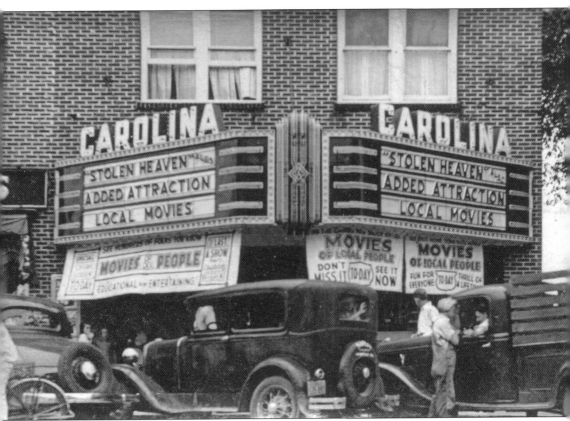

STATE THEATER, 1940s. This reprinted postcard shows the former State Theater. Note the added attraction of local movies on the marquee. This is advertising the films of H. Lee Waters, who, during the Depression, came to town and filmed the people. He would then show the films at the local theater for part of the box money. The films were a hit, as people enjoyed seeing themselves on the big screen.

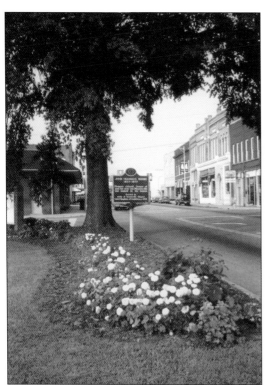

MOORE PARK AND DOWNTOWN, 1980s. This postcard produced in the 1980s shows Moore Park, looking north on Main Street. This postcard was done as part of the downtown development of Mooresville to show the small-town atmosphere and charm. The card has been photoshopped, as evidenced by the lack of traffic lights at the intersection of Main Street and Center Avenue. The plaque in the center of the flowers commemorates John F. Moore and his role in the incorporation of the town.

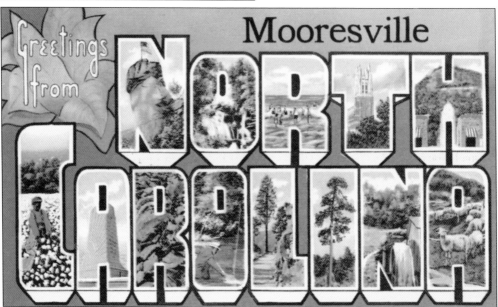

MOORESVILLE, NORTH CAROLINA. This style of postcard was popular from the 1920s through the 1960s. The large block lettering shows sites of North Carolina such as Blowing Rock, the beach, and Kitty Hawk. This example is thought to have been produced in the 1930s and was a general card that was mass-produced that simply stated the town's name and the state. These popular cards were designed to attract visitors not only to the state but also to the town, although no images of the town are on the postcard.

BIBLIOGRAPHY

Haselden, W.J. *Mooresville, North Carolina: The Early Years.* Mooresville, NC: W.J. Haselden, 1967.

Holt, Tonie, and Valmai Holt. *Picture Postcards of the Golden Age.* London, UK: MacGibbon & Kee, 1971.

Prochaska, David, and Jordana Mendelson. *Postcards: Ephemeral Histories of Modernity.* University Park, PA: Pennsylvania State University Press, 2010.

Pyne, Lydia. *Postcards: The Rise and Fall of the World's First Social Network.* London, UK: Reaktion Books, 2021.

Staff, Frank. *The Picture Postcard & Its Origins.* New York, NY: Frederick A. Praeger, 1967.

Stevens, Norman D., ed. *Postcards in the Library: Invaluable Visual Resources.* New York, NY: Routledge, 1995.

Wilson Library Special Collections, UNC University Libraries. dc.lib.unc.edu.

NavSource Naval History. www.navsource.org.

Discover Thousands of Local History Books
Featuring Millions of Vintage Images

Arcadia Publishing, the leading local history publisher in the United States, is committed to making history accessible and meaningful through publishing books that celebrate and preserve the heritage of America's people and places.

Find more books like this at
www.arcadiapublishing.com

Search for your hometown history, your old stomping grounds, and even your favorite sports team.

Consistent with our mission to preserve history on a local level, this book was printed in South Carolina on American-made paper and manufactured entirely in the United States. Products carrying the accredited Forest Stewardship Council (FSC) label are printed on 100 percent FSC-certified paper.

MADE IN THE